IMAGES
of Rail

SCRANTON RAILROADS

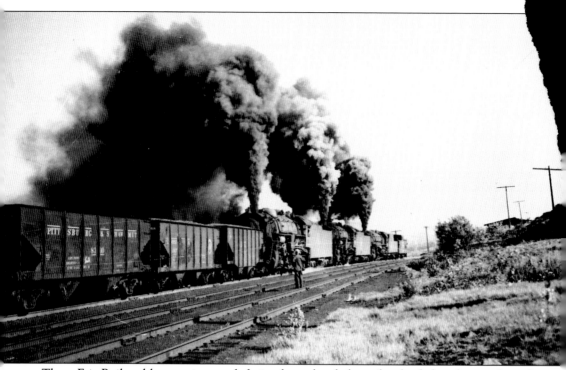

Three Erie Railroad locomotives work furiously as they help push a loaded coal train through Forrest City. The combination of steep grades and heavy coal trains often required the use of pushers on the Erie's Jefferson division, also used by the Delaware and Hudson Railroad. This 1940 scene typifies the effort required to move coal out of Scranton and the surrounding Lackawanna Valley. (Railroad Museum of Pennsylvania, Pennsylvania Historical and Museum Commission, reprinted with permission.)

On the cover: There is plenty of work to go around in this 1922 view inside the Scranton erecting shops of the Delaware, Lackawanna and Western Railroad. Rendered obsolete in the mid-1950s as the nation's railroads converted to diesel power, this building was sold by the railroad and became the Chamberlain Ammunition plant, manufacturing artillery shells. (Railroad Museum of Pennsylvania, Pennsylvania Historical and Museum Commission, reprinted with permission.)

IMAGES
of Rail

SCRANTON RAILROADS

David Crosby

ARCADIA
PUBLISHING

Published by Arcadia Publishing
Charleston, South Carolina

Printed in the United States of America

Library of Congress Control Number: 2008943875

For all general information contact Arcadia Publishing at:
Telephone 843-853-2070
Fax 843-853-0044
E-mail sales@arcadiapublishing.com
For customer service and orders:
Toll-Free 1-888-313-2665

Visit us on the Internet at www.arcadiapublishing.com

To Candace for her constant support

CONTENTS

ACKNOWLEDGMENTS

This book would not have been possible were it not for the input and assistance of several people. Steamtown National Historic Site park rangers Ken Ganz and Tim O'Malley have contributed their extensive knowledge of Scranton's industrial and cultural history. Park superintendent Kip Hagen is thanked for his support and making the site's staff and archives available to the author. Kurt Bell, archivist at the Railroad Museum of Pennsylvania, proved an invaluable resource as he guided the author through the Tabor Collection at the museum's archives. Likewise, the author would like to thank Mary Ann Moran-Savakinus and her staff at the Lackawanna Historical Society for making their collection available and retrieving many priceless images for this project. Providing further assistance and information were Andrew Ottinger, Dominic Keating, Robert Tomaine, Patrick McKnight, Richard Stanislaus, Edward S. Miller, Earl Trygar, Lawrence Malski, and David Monte Verde. The author would also like to thank his high school English teacher, Ann Langan, whose senior writing class made this book possible.

INTRODUCTION

Scranton, nestled in the picturesque valley of the Lackawanna River, was built literally and figuratively on a foundation of anthracite coal. It was the abundance of this hard coal that attracted business and industry to the area for over a century and was the primary reason five railroads eventually served what came to be known as the "Anthracite Capital of the World."

The coal industry in the area predates conventional railroads by a generation. While canal boats were the chosen method of transport elsewhere in the opening decades of the 19th century, the mountains surrounding the Lackawanna Valley made such transport impractical. It was for this reason that so-called gravity railroads were constructed to haul coal from area mines to the nearest canals. Gravity railroads involved a process whereby coal cars would be hoisted to the top of a hill or plane by a stationary steam engine and then allowed to coast downhill to their next destination, which was often another incline. The Delaware and Hudson Canal Company completed its gravity railroad in 1829, and by the 1840s, this system allowed 200,000 tons of coal per year to be shipped from Carbondale over the mountains to Honesdale, about 25 miles northeast of present-day Scranton. It was on a level section of this gravity railroad that the first operation of a steam locomotive in North America took place.

In an early experiment in conventional locomotion, the Delaware and Hudson Canal Company ordered four locomotives from builders located in the United Kingdom. The first of these locomotives to be assembled and tested in America was the *Lion*, manufactured by Foster Rastrick and Company of Stourbridge, England. On August 8, 1829, the locomotive commonly referred to as the "Stourbridge Lion" secured its place in history as the first steam locomotive to operate in the United States. While the machine itself performed well, operation of the Stourbridge Lion was doomed from the beginning. At nearly eight tons in weight, it was almost twice as heavy as its owners' design specified. The tracks of the gravity railroad were not designed to support this amount of weight, and so the operation of steam locomotives on this specific line was not to be. However unsuccessful those tests were, the railroad movement was well underway in America. In 1830, the Baltimore and Ohio Railroad opened what is widely considered to be the nation's first conventional railroad in the state of Maryland. It would be another 20 years, however, before a true locomotive railroad was constructed in Scranton.

In 1840, Sanford Grant, William Henry, and George and Seldon Scranton founded the Scrantons, Grant and Company and constructed an iron furnace in what is now Scranton, thus setting in motion a series of events that led to the construction of the first conventional railroad in the valley. In part lured to what was then known as Slocum Hollow by unsubstantiated claims of large deposits of quality iron ore, the investors did not achieve financial success during their

first several years in business. This changed in the mid-1840s as the New York and Erie Railroad was struggling to complete a line from the Hudson River to Binghamton, New York, before a deadline of December 31, 1848. Because virtually all iron rails for the nation's rapidly expanding rail network were imported from England, itself laying tracks at a breakneck pace, the builders of the New York and Erie were hampered by short supplies and long delays. The Scrantons had the foresight to recognize the need for a reliable supply of rails produced stateside and began modifying their ironworks to meet this demand. In 1846, the Scrantons signed a contract to supply the New York and Erie with 16,000 tons of iron rail at $65 per ton. More contracts followed, saving not only the railroad but most likely the ironworks as well. The Scrantons then turned to developing an efficient way to deliver their products to market.

Originally chartered in 1832, the Liggetts Gap Railroad was planned to run from the mountains east of Slocum Hollow, pass through the town, and continue to the New York State line. Lack of capital delayed construction until 1850, when the Scrantons invested in the line as a way to move their products to market. The Liggetts Gap soon became the Lackawanna and Western Railroad, and trains were running to Great Bend on the New York State line by October 1851. In 1853, the Lackawanna and Western acquired the planned Delaware and Cobb's Gap Railroad, slated to run east to the Delaware Water Gap. The combined company was called the Delaware, Lackawanna and Western Railroad and was running trains into New Jersey by 1856, the same year Slocum Hollow officially became Scranton.

By 1865, the ironworks boasted the largest production capacity of any iron furnace in America. Still hampered by a need to transport quality iron ore to the Scranton furnaces, in 1902 the company, by then known as the Lackawanna Iron and Steel Company, disassembled its operation in Scranton and moved to Lackawanna, New York. This provided easier access to raw materials from the Missabe iron range via Lake Erie. By 1902, though, the Delaware, Lackawanna and Western was more than capable of standing on its own, having tapped into the lucrative anthracite trade almost immediately after its inception.

Other railroads soon found their way into Scranton to claim their share of the anthracite business. In 1860, the Delaware and Hudson Canal Company built a locomotive railroad between Providence, a suburb of Scranton, and its gravity railroad, which by then had been extended to Olyphant, about seven miles to the north of Scranton. Service to downtown Scranton followed three years later. Eventually the Delaware and Hudson developed an alternate locomotive-only route to New York State in cooperation with the Erie Railroad. This operation, at first called the Jefferson Railroad, was so successful that it allowed the Delaware and Hudson to abandon its gravity system by 1899. The competing Pennsylvania Coal Company built a conventional railroad, known as the Erie and Wyoming Valley Railroad, along one of its own gravity railroads in 1864. The Erie Railroad eventually acquired control of the Pennsylvania Coal Company and its Erie and Wyoming Valley line. The New York, Ontario and Western Railway completed a route from its main line in New York State to Scranton in 1880. The Central Railroad of New Jersey was last to arrive by gaining control of several smaller companies in order to reach the anthracite coalfields in 1888.

Over a 150-year period beginning in 1820, it is estimated that over three billion tons of anthracite coal were mined in northeastern Pennsylvania. This equates to roughly 85 percent of the nation's output of hard coal. Due to its low sulfur content, anthracite coal burns hotter, longer, and cleaner than bituminous or soft coal. Many specialized uses were found for hard coal, including glassblowing and sugar refining. By World War I, anthracite was the preferred fuel for military ships at sea due to its clean burning properties. Less smoke being emitted from a ship's stack meant less chance of being spotted by an enemy submarine. So great was the demand for this fuel that in 1917, the peak year of production, more than half of all working males in the Lackawanna Valley were employed by the coal industry.

In 1902, the Lackawanna and Wyoming Valley Railroad began operations from Scranton, providing not only high-speed interurban transit but local freight service as well. Known commonly as the Laurel Line, the route eventually connected Scranton with Wilkes-Barre about

20 miles to the south. A second branch of the third-rail electric line was planned to reach as far north as Carbondale but saw track constructed only as far as Dunmore, a few miles north of Scranton. In 1905, the company opened a nearly mile-long tunnel under south Scranton that further expedited traffic on the line by eliminating a cumbersome routing out of the city. Two amusement parks were served by the Laurel Line: Luna Park just to the north of Scranton proper and Rocky Glen Park about seven miles to the south. While Luna Park closed in 1916, Rocky Glen continued operating under various auspices until the late 1980s.

By the dawn of the 20th century, the railroad had become intertwined in the everyday lives of those living in the region. Deliveries such as milk, fresh meat, produce, and even whole houses by way of Sears, Roebuck and Company made their way from the outside world to the streets of northeastern Pennsylvania. Ample labor, land, and a means to transport goods also attracted the textile industry as dozens of silk mills and lace factories were constructed in the valley. As the railroad industry grew, it became one of the area's largest employers, second only to the coal industry itself. Working for the railroad was simply a way of life for many men and women, and most every resident had a family member who worked for a railroad in one way or another. Riding the train became the fastest, not to mention most glamorous, way to travel. Railroads were at the beginning of most every journey; they brought relatives for a visit and took others off to work.

After surviving the Great Depression, railroads were called upon to serve the nation on an unprecedented scale. The World War II years are regarded by many as the railroads' finest hour as they transported 97 percent of the nation's soldiers to war. Lines that had teetered on the brink of collapse a decade prior were now moving men and machinery like never before. Locomotives that sat idle and were destined for the scrap yard were pressed into service once again.

At the dawn of the 1950s, the region's railroads were well into the process of replacing their steam locomotives with diesel-electric units. Prior to the war, several builders, most notably the Electro-Motive Division of General Motors, were demonstrating this new form of motive power on the nation's railroads. Only wartime production restrictions prevented the wholesale retirement of the steam locomotive in the 1940s. By 1944, however, the tide had turned, and for the first time, more diesel locomotives were constructed than steam. After the war ended, railroads began to purchase diesels as quickly as they could afford to. The shops and roundhouses, built specifically to maintain steam power, were now rendered obsolete by internal combustion technology. Many such facilities were closed, torn down, sold for other uses, or in some cases simply abandoned and allowed to deteriorate in place. Since it took fewer people to operate, service, and repair diesels, many jobs were simply eliminated.

The years after World War II saw radical changes not only in the nation's economy but its very spirit as a whole. Passenger trains would come to be seen as little more than a quaint symbol of the past as Americans embraced the automobile as the primary means of transportation. Even as the nation's railroads promoted streamlined trains with new diesel-electric locomotives, passenger traffic continued its downward spiral. One by one Scranton's railroads exited the passenger business. As an example, the Delaware and Hudson at one time operated a network of passenger trains in the area. By the late 1940s, however, only a Scranton-to-Carbondale commuter service was offered by the company with antiquated locomotives and wooden cars reminiscent of 50 years prior. By 1952, even that was service was discontinued. The Lackawanna and Wyoming Valley ended passenger service in December of the same year. Finally, in 1970, the last regularly scheduled passenger train, operated by the now merged Erie-Lackawanna Railroad, departed Scranton for good.

Perhaps an even bigger blow to the railroads was the dramatic decline of the anthracite coal traffic. At the same time railroads were switching to diesel power, the nation was embracing new means of producing heat and power. America invested heavily in liquid fuels while electricity was brought to even the most rural homesteads, greatly diminishing the demand for hard coal. A dramatic punctuation to this decline came on January 22, 1959, when the Susquehanna River broke through a tunnel owned by Knox Mine Company near Pittston after miners dug too close

to the riverbed above them. In what became known as the Knox Mine Disaster, 13 men lost their lives and an extensive network of underground mines was flooded.

All this took place at the same time railroads were struggling to compete with the burgeoning trucking industry, which enjoyed a relatively free ride on America's Interstate Highway System. As the loss of passenger and coal traffic continued through the 1950s, it seemed at times as if even Mother Nature had a grudge with the railroads. In 1955, Hurricane Diane washed out much of the Delaware, Lackawanna and Western east of Scranton into New Jersey. The resulting month-long shutdown and astronomical expense of reopening the line crippled the company financially. In 1960, unable to survive on its own, the Delaware, Lackawanna and Western merged with a longtime rival, the Erie Railroad, to form the Erie-Lackawanna. The New York, Ontario and Western Railway shut down in its entirety in 1957. The Lackawanna and Wyoming Valley became a part of the Delaware, Lackawanna and Western in 1959 and was almost entirely abandoned over the next decade. In 1972, the Central Railroad of New Jersey abandoned its route into Scranton.

In 1976, the United States government created the Consolidated Rail Corporation, or Conrail, from the tattered remains of the Central Railroad of New Jersey, Erie-Lackawanna, Lehigh Valley, Reading, Penn Central, and Lehigh and Hudson River Railroads. Conrail slowly curtailed operations in the Scranton area, eventually ending operations on the former Delaware, Lackawanna and Western tracks in favor of other less-mountainous routes. At the same time, the Delaware and Hudson acquired the portion of the former Delaware, Lackawanna and Western between Scranton to Binghamton. Due to its steeper grades, the Delaware and Hudson eventually abandoned most of its original main line in Pennsylvania in favor of this new route. To preserve local freight service north of Scranton, the Lackawanna County Railroad Authority purchased a portion of the now unwanted line. The Delaware and Hudson itself entered bankruptcy in the late 1980s after being controlled for some time by the Guilford Rail System of New England. In 1991, the giant Canadian Pacific Railway completed its purchase of Delaware and Hudson, which until that time had been America's oldest continually operated transportation company.

Through strategic mergers, innovative thinking, and perhaps pure determination, some lines survived the darkest times and were reborn as vital components of the nation's transportation infrastructure. Today trains roll through the hills and valleys surrounding Scranton on a scale unparalleled for several decades. The Canadian Pacific Railway operates the former Delaware and Hudson as an integral part of its transcontinental network while the Reading and Northern Railroad operates some former Conrail trackage. The Pennsylvania Northeast Regional Railroad Authority (formerly the Lackawanna County Railroad Authority) and its operator the Delaware-Lackawanna Railroad have revitalized the former Delaware, Lackawanna and Western Railroad east of Scranton to the Delaware Water Gap with the line now seeing daily freight runs. The portion of the Delaware and Hudson saved in the 1980s also sees daily activity.

In 1984, Steamtown USA, a railroad museum and excursion operator, moved from its longtime home in Vermont to the remnants of the Delaware, Lackawanna and Western Scranton yard. In 1986, after several years of instability, the entire rail yard and vintage locomotive collection became Steamtown National Historic Site, a unit of the National Park Service. Even the old Laurel Line has been reborn as both a freight carrier and trolley excursion operated by the Delaware-Lackawanna Railroad for several miles south of Scranton.

This book endeavors to illustrate the railroad network in and immediately surrounding Scranton; it is a fascinating legacy, best told in photographs.

One

WHY BUILD A RAILROAD

The principal reason for the construction of any railroad is simple: it is built to move large quantities of something from one location to another. Those commodities may be any number of things such as iron ore, grain, crude oil, or even the traveling public. In the case of the Lackawanna Valley and its largest city, Scranton, those items were coal and iron.

The Delaware and Hudson Canal Company and the Pennsylvania Coal Company were the first to harvest the area's riches through their respective gravity railroad systems. This method employed a system of pulleys and cables to pull cars to the top of a hill or plane. Once they reached the top of the grade, gravity took charge, and these cars coasted to their next destination, kept under control by manual brakes operated by an onboard crew. An extensive network of these inclines, called planes, was developed, with designated routes for loaded cars and lite tracks for empty cars. These unconventional systems moved not only coal but also construction materials and finished goods to and from the area. The general public soon discovered the pleasure of riding what was not unlike a modern-day roller coaster as stations and passenger cars were constructed specifically for the benefit of the traveling public. In 1829, the Delaware and Hudson became the first company to operate a steam locomotive when it conducted test runs with an engine known as the Stourbridge Lion.

In the early 1840s, the abundance of anthracite coal attracted the iron industry to the Lackawanna Valley. In 1851, the fledgling iron business compelled the construction of the first conventional locomotive railroad in the area, a line that would soon be known as the Delaware, Lackawanna and Western Railroad. The Lackawanna Railroad, as it was more commonly known, was financed largely by the iron industry as a way to deliver its products to market. The ironworks, initially organized as Scrantons and Platt, developed a sprawling complex that eventually occupied much of south Scranton. Later known as the Lackawanna Iron and Coal Company and finally the Lackawanna Iron and Steel Company, the organization closed the Scranton works and relocated to New York State in 1902. By this time, however, the Lackawanna Railroad was a major player in the anthracite coal trade and was able to withstand the loss of the iron and steel traffic.

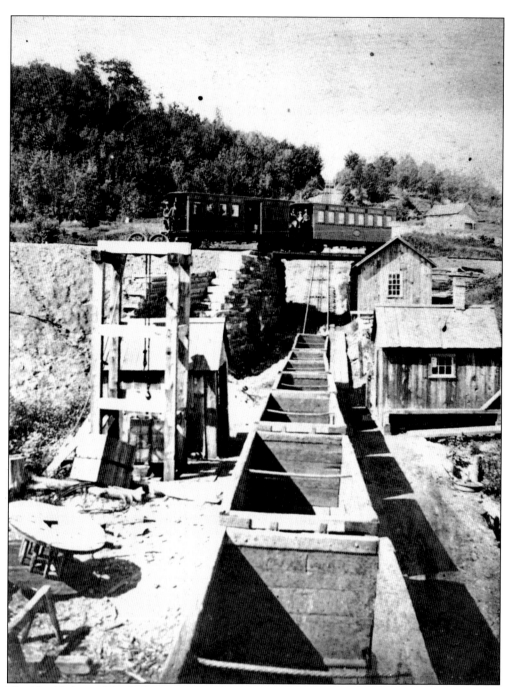

The No. 16 plane of the Delaware and Hudson Canal Company's gravity railroad is shown in this c. 1870 photograph. A train of empty, or lite, coal cars is at the base of an inclined plane while a passenger train passes overhead. Behind the empty cars is the cable mechanism used to pull them uphill. In many areas such as this, the Delaware and Hudson constructed separate tracks for loaded and empty cars to allow for efficient bidirectional operation. The two-car passenger train seen here is coasting down the so-called loaded track. (Railroad Museum of Pennsylvania, Pennsylvania Historical and Museum Commission, reprinted with permission.)

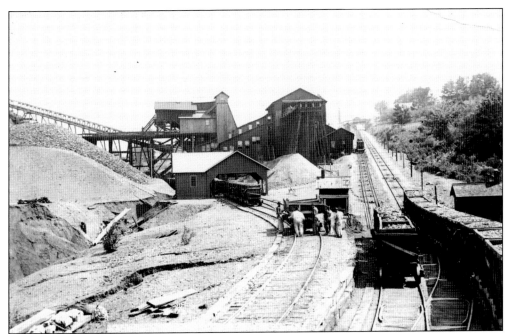

The No. 4 plane of the Delaware and Hudson gravity railroad was a busy place when this c. 1880 photograph was taken. Coal cars are being loaded at the facility on the left and are then staged for transport uphill as shown to the right. (Lackawanna Historical Society collection.)

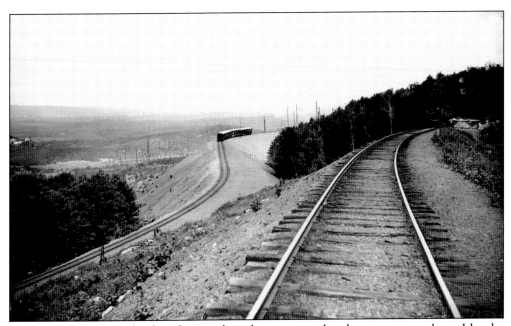

Originally designed to haul coal to market, the gravity railroads were soon embraced by the traveling public and sightseers. Perhaps the most scenic location on the Delaware and Hudson gravity railroad was the hairpin turn known as "Shepard's Crook." In this scene, a passenger train rolls downgrade on the lite track, that portion of the line used to return empty coal cars to the Lackawanna Valley for reloading. (Lackawanna Historical Society collection.)

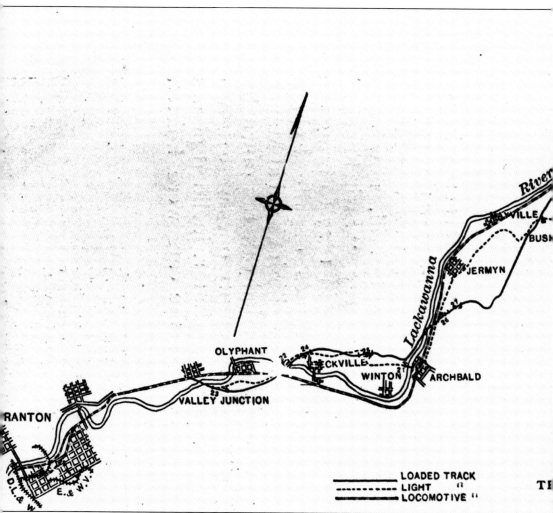

The Delaware and Hudson Canal Company's gravity railroad grew into a sprawling network that connected the cities of Honesdale, Carbondale, and Olyphant. At Valley Junction, near Olyphant, the company constructed a conventional railroad that ran for several miles south to the city of Scranton. On the opposite end of the system was Honesdale, where coal would

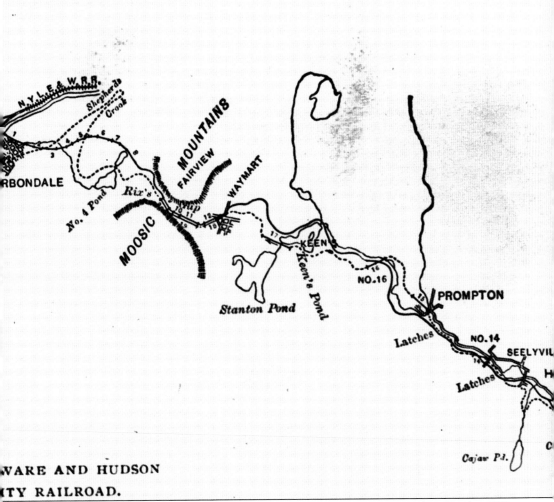

WARE AND HUDSON

ITY RAILROAD.

be transferred to barges on the Erie Canal to complete the journey to market. By the 1870s, conventional locomotion had been embraced by a number of lines serving Scranton, as shown in this illustration. (Railroad Museum of Pennsylvania, Pennsylvania Historical and Museum Commission, reprinted with permission.)

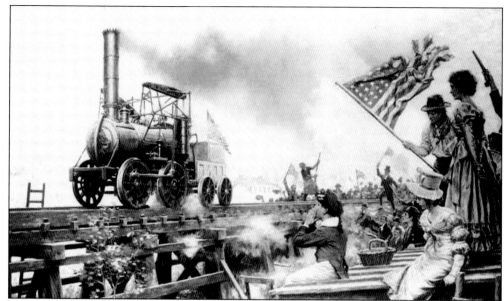

In 1916, artist Clyde Osmer DeLand painted this fanciful illustration of the Stourbridge Lion's first test run of 1829. As photography had not yet been invented, written accounts of the day provide the only true insight into this historic event. While the painting makes for a stirring, patriotic image, many of the spectators were convinced the locomotive would be a failure and perhaps even kill anyone riding it. (Railroad Museum of Pennsylvania, Pennsylvania Historical and Museum Commission, reprinted with permission.)

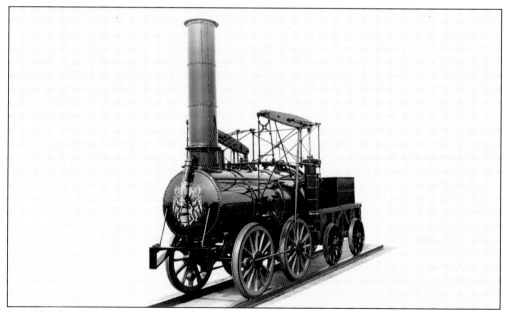

In 1933, after thorough research and investigation, the Delaware and Hudson Canal Company constructed an operational reproduction of the Stourbridge Lion for display and exhibition. The replica is now on display at the Wayne County Historical Society in Honesdale. (Railroad Museum of Pennsylvania, Pennsylvania Historical and Museum Commission, reprinted with permission.)

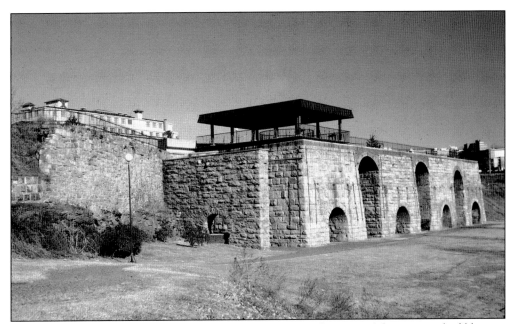

The iron- and steel-making process began at these stone furnaces. After a period of blasting raw ore in the furnaces, the resulting iron "pigs" would be transported to other sections of the complex to be fashioned into marketable products such as T rails. When the Lackawanna Iron and Steel Company left Scranton in 1902, the only trace left behind was the original stone blast furnaces seen here. (National Park Service, photograph by Ken Ganz.)

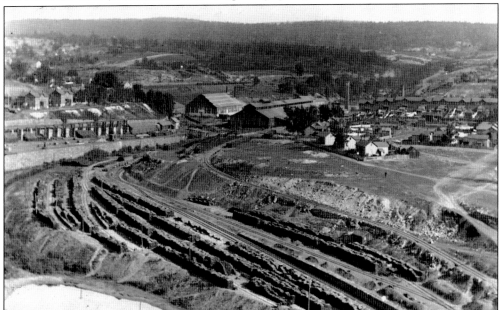

After cooling, the iron pigs were taken from the blast furnaces to the storage yard shown here. When needed, they were taken via a narrow-gauge railway to a complex in the background of this photograph for further processing. After the closure of the Scranton works in 1902, a portion of the narrow-gauge railway grade was used to construct the Lackawanna and Wyoming Valley Railroad grade. (Lackawanna Historical Society collection.)

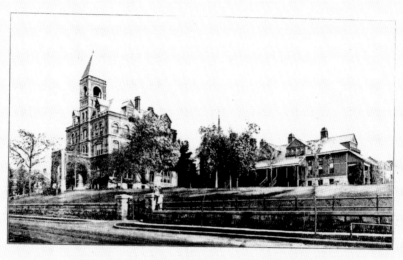

MOSES TAYLOR HOSPITAL, SCRANTON, PA.

THIS IS A FREE HOSPITAL FOR THE BENEFIT OF THE EMPLOYEES OF THE

DELAWARE, LACKAWANNA AND WESTERN RAILROAD COMPANY

AND THE

LACKAWANNA IRON & STEEL COMPANY

AND FAMILIES WHOLLY DEPENDENT UPON THEM

RULES FOR THE ADMISSION OF PATIENTS—Applicants eligible to the privileges of the Hospital desiring admission either for themselves or for their families as house patients, should first procure a letter of identification from the foreman, or officer to whom they report. This letter must be approved for employees of the D., L. & W. R. R. Co. by the Vice-President, the General Superintendent or the General Manager or Superintendent of the Coal Mining Department; and for the L. I. & S. Co. by the General Manager.

Those who do not desire to remain in the Hospital can receive medical attendance upon application at the Hospital Dispensary, by presenting a letter of identification from the head of the Department in which they are employed. Emergency cases will receive proper attention upon telephone or personal application to the Hospital, where an ambulance is always in readiness.

CHARGES—If private rooms are desired, a charge will be made of $10.00 to $15.00 per week, according to the rooms. Doctors on Hospital Staff will have privileges of the Hospital, on approval of the Executive Committee, for their private patients, where there is room, at the following rates: Wards, $7.00 per week; private rooms, $15.00 to $25.00 per week, according to the location.

REGULATIONS FOR VISITORS—Regular visiting days at the Hospital for patients in the general ward will be Tuesdays, Fridays and Sundays, from 2 to 4 o'clock in the afternoon. Visitors will be admitted to patients in private rooms every afternoon and evening until 9 o'clock.

REGULAR HOURS AND DAYS FOR ADMISSION OF PATIENTS:

(1). For those desiring to remain in wards, 2 o'clock p. m. on Tuesdays and Saturdays. (Patients will not be admitted at other hours except in cases of emergency).

(2). For medical treatment in dispensary, 2 o'clock p. m. on Tuesdays and Saturdays.

(3). For treatment of eye, ear, nose and throat, 2 o'clock p. m. on Wednesdays.

(4). For X-ray examination or treatment, 1:30 o'clock p. m. on Mondays and Fridays.

(5). For surgical dressings, 9 o'clock a. m. on Tuesdays and Fridays.

(6). Emergency cases will be admitted at any time, day or night.

MOSES TAYLOR,
PRESIDENT.

E. E. LOOMIS,
SECRETARY AND TREASURER.

In 1892, Moses Taylor, then president of the Delaware, Lackawanna and Western Railroad, founded the Moses Taylor Hospital in Scranton. As a gesture of goodwill, this hospital offered free medical services to the employees of the Delaware, Lackawanna and Western Railroad. Note the inclusion of workers from the Lackawanna Iron and Steel Company, as both companies were a united venture at the time. (Railroad Museum of Pennsylvania, Pennsylvania Historical and Museum Commission, reprinted with permission.)

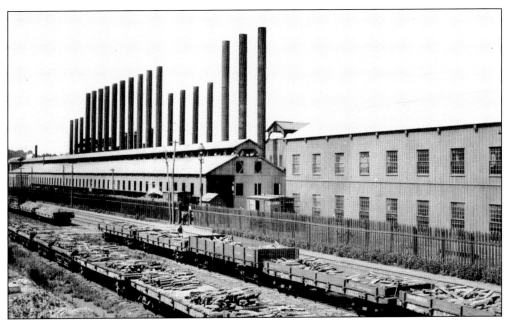

In 1881, William Walker Scranton, the Lackawanna Iron and Coal Company's general manager and son of founder Joseph H. Scranton, left that firm and organized the Scranton Steel Company. The company's Bessemer converters, which processed iron into steel, are seen here in 1886. Scranton Steel was located approximately one mile south of the Lackawanna works along Roaring Brook. (Lackawanna Historical Society collection.)

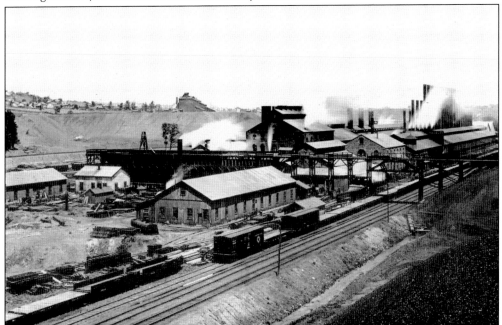

In 1891, the Lackawanna Iron and Coal Company and the Scranton Steel Works merged to form the Lackawanna Iron and Steel Company. The former Scranton Steel site became known as the south works, seen here around 1894. This firm was the third-largest steelworks in the nation by the time this photograph was taken. (Lackawanna Historical Society collection.)

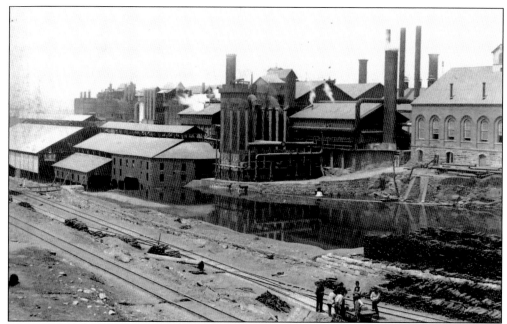

The Lackawanna Iron and Steel Company is shown here at its zenith in 1892, maintaining a sprawling complex on the banks of Roaring Brook. Despite having an extensive physical plant, the company was still hampered by the need to transport raw materials to the Scranton site. (Lackawanna Historical Society collection.)

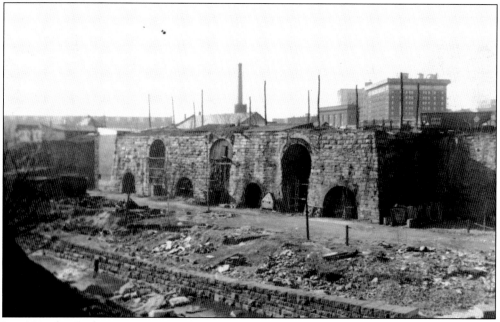

In 1902, the Lackawanna Iron and Steel Company moved to Lackawanna, New York, on the shores of Lake Erie. This satisfied the company's need to be closer to the raw materials shipped from Michigan's Missabe iron range. After the company's relocation, the only remnants of Scranton's iron industry were the original stone blast furnaces, seen here around 1915. (Lackawanna Historical Society collection.)

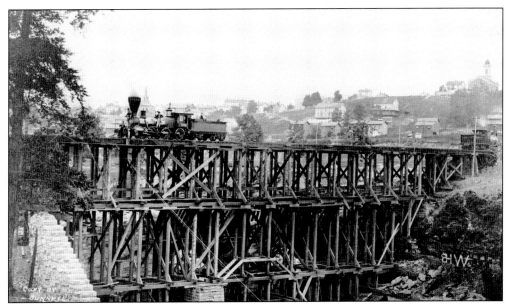

To cross the Lackawanna River, the Delaware, Lackawanna and Western Railroad constructed a wooden trestle located at the west end of its rail yard in downtown Scranton. This 1866 view shows a typical steam locomotive of the day on the wooden span. This bridge would be replaced in several years by a more substantial stone arch structure, which itself would be replaced in 1908 by a steel span. (Railroad Museum of Pennsylvania, Pennsylvania Historical and Museum Commission, reprinted with permission.)

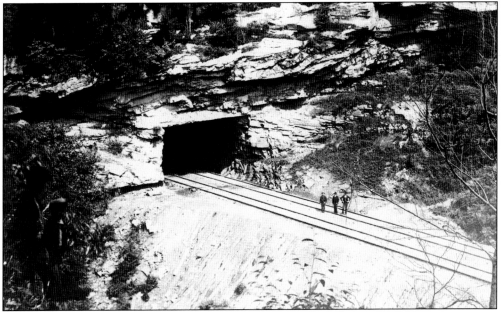

The rocky terrain east of Scranton proved a significant obstacle to overcome during the eastward construction of the Delaware, Lackawanna and Western. As seen here, the landscape required construction of one of the nation's earliest railroad tunnels. Completed in 1856, the Nay Aug tunnel was at first a single bore; a second tunnel was added in 1906. (Railroad Museum of Pennsylvania, Pennsylvania Historical and Museum Commission, reprinted with permission.)

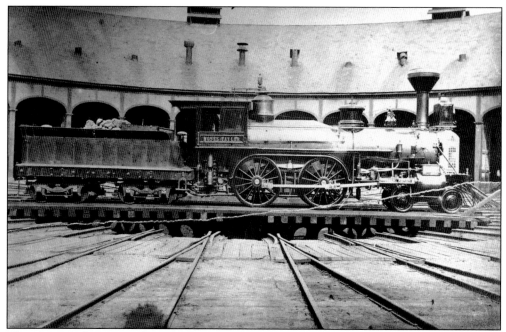

The *Moses Taylor*, a typical Civil War–era locomotive, is seen at an unidentified roundhouse in this photograph. In typical practice of the day, the Delaware, Lackawanna and Western Railroad locomotive was named for a person of prominence, in this case the president of the railroad. (Steamtown National Historic Site collection.)

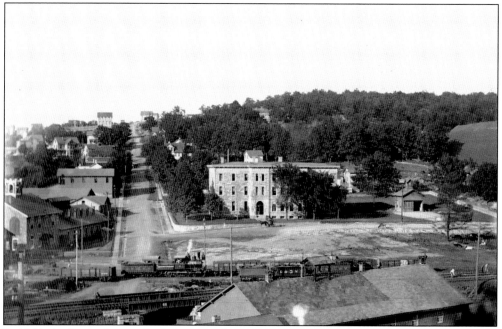

In 1864, the Pennsylvania Coal Company began construction of the Erie and Wyoming Valley Railroad as a means of transporting anthracite. This *c.* 1892 photograph shows the offices of the Pennsylvania Coal Company and the locomotive shops of the Erie and Wyoming Valley in Dunmore. (Lackawanna Historical Society collection.)

Two

ANTHRACITE BUILDS A RAILROAD TOWN

The Delaware, Lackawanna and Western Railroad became the first railroad to directly serve Scranton in 1851. The Delaware and Hudson Railroad arrived a decade later with a locomotive railroad. The Erie and Wyoming Valley Railroad also arrived in the 1860s; built along the Pennsylvania Coal Company's gravity route, this company was soon controlled by the giant Erie Railroad. The New York, Ontario and Western Railway soon followed suit and finished its line to Scranton in 1880. In 1888, the Central Railroad of New Jersey completed its route into the city.

Each company offered its own passenger service. The Erie and Wyoming Valley built a modest station just north of downtown Scranton on Washington Avenue. The Central Railroad of New Jersey and the New York, Ontario and Western shared a depot on the west end of Lackawanna Avenue in downtown Scranton. The Delaware and Hudson station was less than a block to the east on the same street. Across the street from that station were the facilities for the Delaware, Lackawanna and Western. In 1900, that company introduced Phoebe Snow, a fictional character who appeared in advertisements and photographs dressed in pristine white gowns extolling the virtues of the railroad's clean anthracite-fired locomotives.

While many products were carried along the tracks, it was coal that fed the railroads' coffers in addition to feeding their locomotives. Oftentimes the corporate lines of railroad and coal companies intertwined to such a degree that it was difficult to tell the two apart. The Delaware and Hudson Railroad and the Hudson Coal Company were also essentially one in the same. The Delaware, Lackawanna and Western had coal-mining subsidiaries operating under its own name in what was common practice at the time. This close relationship continued into the early 1900s when antitrust laws demanded the separation of the coal and rail interests, at least on paper.

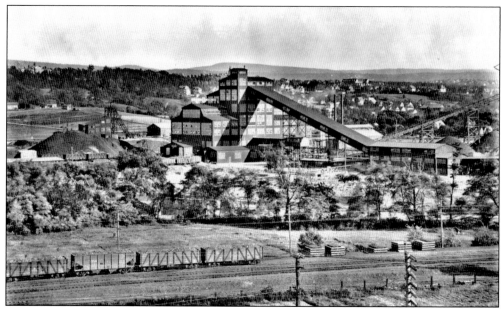

The Hudson Coal Company's Marvine breaker is viewed from a hillside looking southeast. In the foreground of the photograph is the main line of the Delaware and Hudson Railroad. Photographer John Horgan was employed by Hudson Coal to create a visual record of the company's assets, and today these images are of incalculable historic value. (Pennsylvania Anthracite Heritage Museum, Pennsylvania Historical and Museum Commission.)

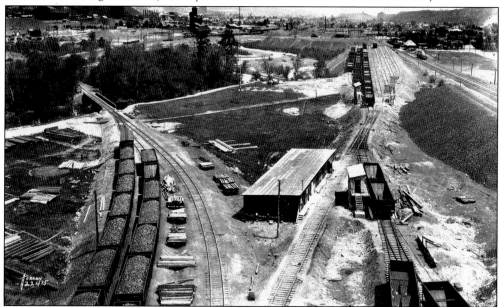

This view looking north from the Marvine breaker shows the empty, or lite, yard with cars staged for loading. In the lower right is a scale, used to weigh empty hopper cars. After loading, the cars were weighed again, with the difference between the two measurements indicating how much coal was loaded. On the left are loaded cars, waiting to be shipped on the Delaware and Hudson. (Pennsylvania Anthracite Heritage Museum, Pennsylvania Historical and Museum Commission.)

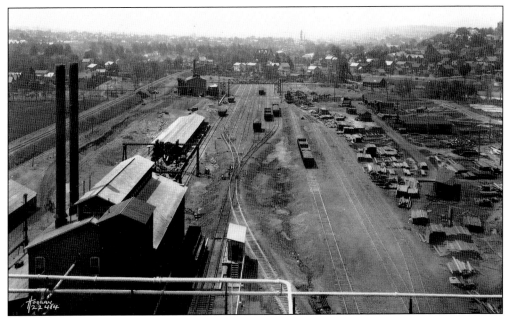

The loading of railcars at various collieries was indeed a well-orchestrated production. Looking south from the top of the Marvine breaker, loaded hopper cars are staged for pickup by the Delaware and Hudson Railroad, visible in the upper right. On the left is the New York, Ontario and Western Railway's Scranton division. (Pennsylvania Anthracite Heritage Museum, Pennsylvania Historical and Museum Commission.)

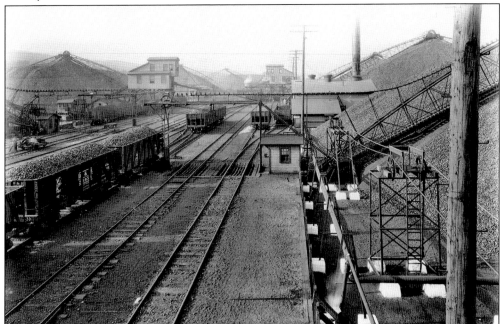

Vast supplies of coal wait to be loaded into railroad cars in this 1920s photograph at a Hudson Coal storage yard. The ladderlike structures atop the coal piles are actually dual-purpose conveyers that could either empty or load hopper cars depending on market demand. (Pennsylvania Anthracite Heritage Museum, Pennsylvania Historical and Museum Commission.)

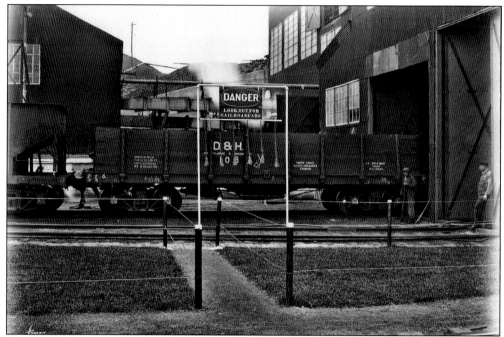

The movement of railcars in and around collieries presented a constant hazard to employees as illustrated here at the Hudson Coal Company's Loree colliery. Note the rope tassels hanging from the warning sign along the walkway, intended to remind workers of the potential danger that lie ahead. (Pennsylvania Anthracite Heritage Museum, Pennsylvania Historical and Museum Commission.)

Illustrating the intersecting interests of both mines and railroads is this mine rescue car belonging to the Delaware, Lackawanna and Western Railroad. This car could be quickly dispatched to render medical aid to any of the numerous mines along the railroad. (Steamtown National Historic Site collection.)

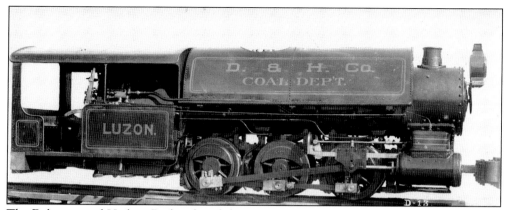

The Delaware and Hudson Railroad coal department maintained a fleet of small, yet powerful narrow-gauge steam locomotives at various mining operations. The so-called lokies were used to pull loaded coal cars from the mine heads to delivery points on the standard-gauge railroad system. (Railroad Museum of Pennsylvania, Pennsylvania Historical and Museum Commission, reprinted with permission.)

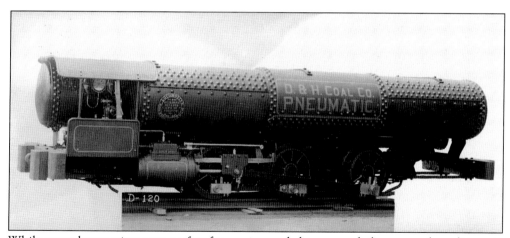

While steam locomotives were perfect for moving coal aboveground, the cramped conditions in the mines themselves required an alternate means of locomotion. In some cases, compressed-air locomotives were used underground, as they required no source of combustion and therefore produced no smoke. (Railroad Museum of Pennsylvania, Pennsylvania Historical and Museum Commission, reprinted with permission.)

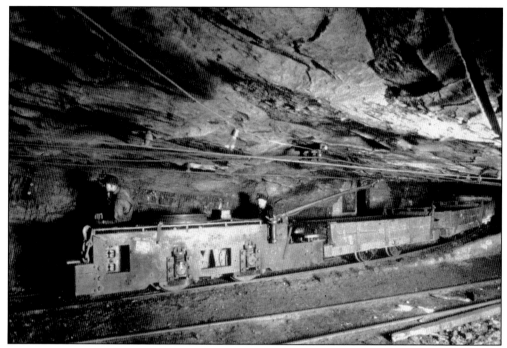

Here an electric locomotive pulls a string of coal cars through a typical mine tunnel. Note the low-hanging electric power lines, one of the many dangers inherent in mining anthracite. (Steamtown National Historic Site collection.)

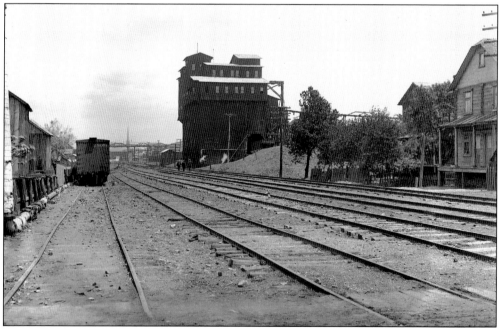

Mines and collieries were located wherever there was a need to harvest coal. This need often resulted in the construction of large imposing structures in the heart of otherwise quiet neighborhoods such as the Delaware, Lackawanna and Western Railroad's diamond colliery as seen here around 1910. (Steamtown National Historic Site collection.)

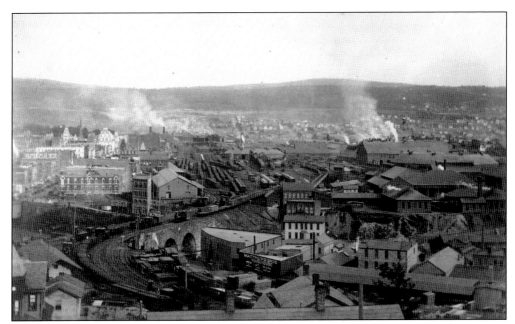

This 1883 view of Scranton shows how extensive the Delaware, Lackawanna and Western's downtown yard became in the years following the Civil War. Looking east, in the center of this image is the original 1855 roundhouse. To the right of the 1855 roundhouse is the shop complex and second roundhouse constructed in 1865. (Railroad Museum of Pennsylvania, Pennsylvania Historical and Museum Commission, reprinted with permission.)

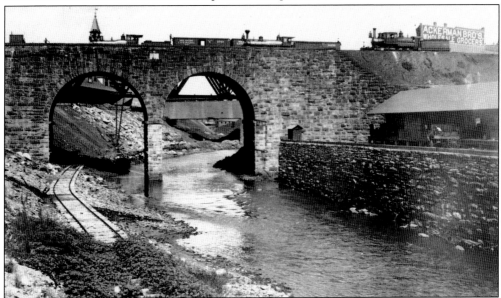

As trains became longer and heavier, the Delaware, Lackawanna and Western Railroad determined the original wooden span across the Lackawanna River was unfit for its growing needs. A sturdier stone arch bridge was constructed in its place during the late 1860s. Several locomotives are seen working high above the Lackawanna River in this c. 1886 image. (Railroad Museum of Pennsylvania, Pennsylvania Historical and Museum Commission, reprinted with permission.)

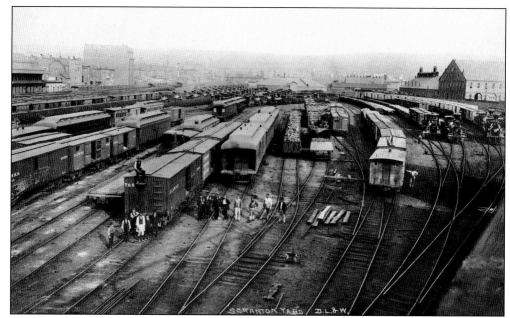

Abhorrent working conditions on the nation's railroads in the 19th century led to the formation of a number of specialized unions for railroad workers. Here a general strike in 1877 has halted operations on the Delaware, Lackawanna and Western Railroad in Scranton. Note the scores of locomotives idled by the strike. (Railroad Museum of Pennsylvania, Pennsylvania Historical and Museum Commission, reprinted with permission.)

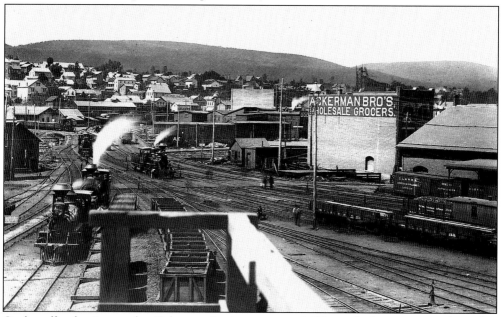

Coal traffic dominates the Delaware, Lackawanna and Western's downtown yard in this late-1880s scene. This view is looking west toward the company's bridge over the Lackawanna River as several groups of loaded and empty coal cars are seen grouped in the foreground. (Railroad Museum of Pennsylvania, Pennsylvania Historical and Museum Commission, reprinted with permission.)

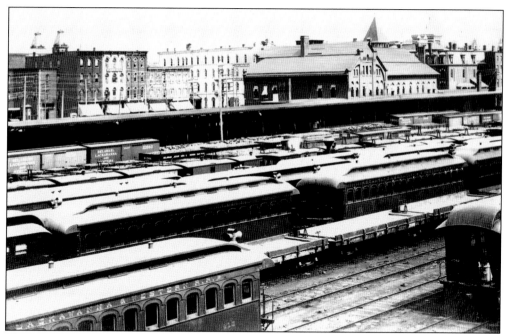

This *c.* 1885 image depicts the Delaware, Lackawanna and Western Railroad's Scranton station as seen from the company's downtown yard. By this time, the railroad boasted a thriving passenger service as seen by the ornate cars awaiting their next call to duty. (Railroad Museum of Pennsylvania, Pennsylvania Historical and Museum Commission, reprinted with permission.)

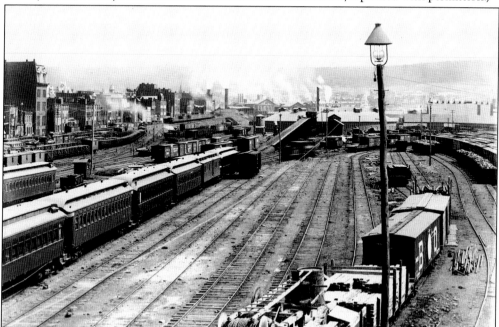

A variety of railroad cars are present in this 1885 view of the Delaware, Lackawanna and Western's "city yard," as the site came to be known. In the center of the photograph is the facility's 1855 roundhouse. (Railroad Museum of Pennsylvania, Pennsylvania Historical and Museum Commission, reprinted with permission.)

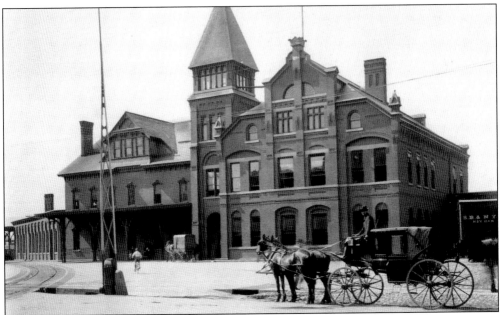

In 1864, the Delaware, Lackawanna and Western Railroad built this ornate station on the west end of its downtown yard, near the Lackawanna River. The station was surrounded by tracks on each side and had a staging area for passenger and freight cars. This late-19th-century view is looking south from the middle of Lackawanna Avenue. (Railroad Museum of Pennsylvania, Pennsylvania Historical and Museum Commission, reprinted with permission.)

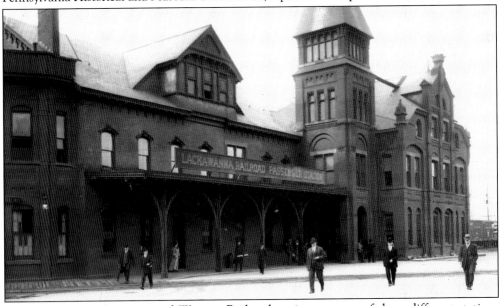

The Delaware, Lackawanna and Western Railroad station was one of three different stations within a one-block stretch of Lackawanna Avenue. The Delaware and Hudson Railroad's terminal was almost directly across the street from the Delaware, Lackawanna and Western's. Just a city block to the west, across the Lackawanna River sat the combined Central Railroad of New Jersey and New York, Ontario and Western Railway depot. (Railroad Museum of Pennsylvania, Pennsylvania Historical and Museum Commission, reprinted with permission.)

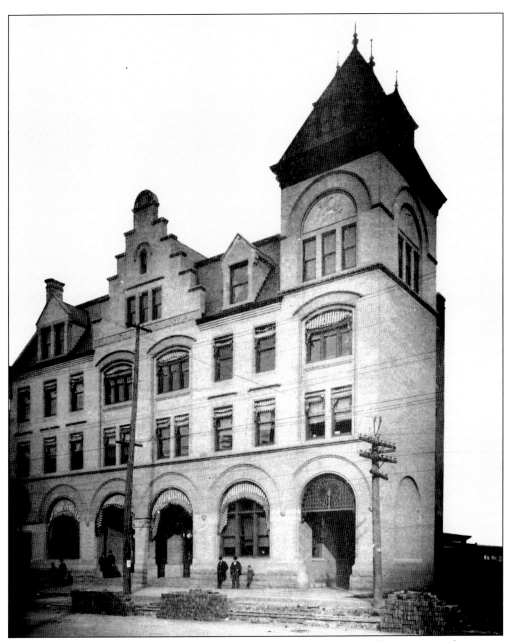

The Delaware and Hudson designed its Scranton terminal to mirror if not surpass the ornate design of its competitor across the street. The Delaware and Hudson used this building until the discontinuance of passenger service in 1952. The 1899 building was demolished in the 1960s. (Lackawanna Historical Society collection.)

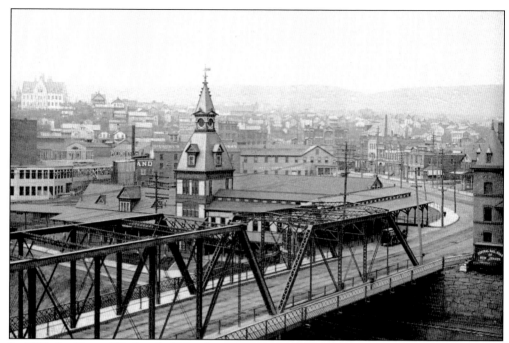

In 1889, the Central Railroad of New Jersey constructed this ornate wooden depot in Scranton along the west bank of the Lackawanna River. In the foreground is the steel truss bridge that carried Lackawanna Avenue over the Lackawanna River, as well as the railroad. (Lackawanna Historical Society collection.)

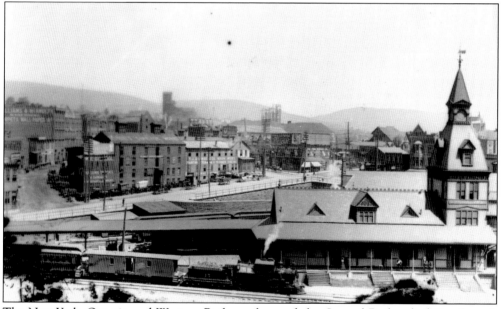

The New York, Ontario and Western Railway also used the Central Railroad of New Jersey's stations in Scranton. In this 1905 photograph, a passenger train belonging to the New York, Ontario and Western is about to depart northbound from the shared depot. (Lackawanna Historical Society collection.)

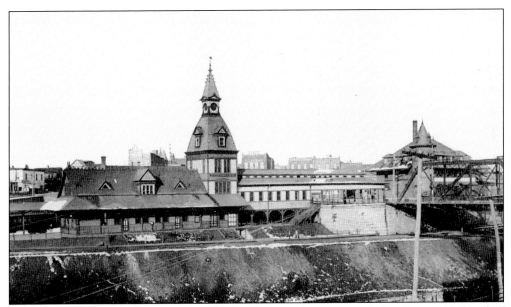

This c. 1900 image is looking across the Lackawanna River toward the Central Railroad of New Jersey passenger station. Visible to the right of the wooden station is the pointed roof and brick turret of the company's freight station, which still stands today. (Lackawanna Historical Society collection.)

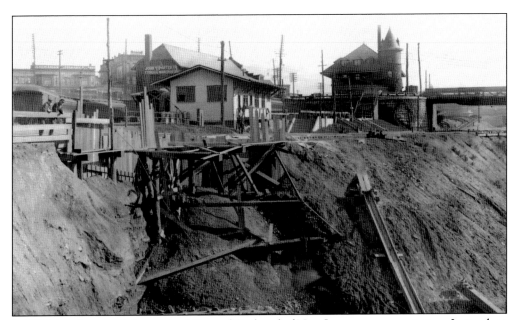

In 1910, fire destroyed the original Central Railroad of New Jersey passenger station. In its place the company built this small, unremarkable structure to serve the traveling public. The building, seen here shortly after its construction, would outlast passenger service on the line and finally be demolished in the early 1970s. (Lackawanna Historical Society collection.)

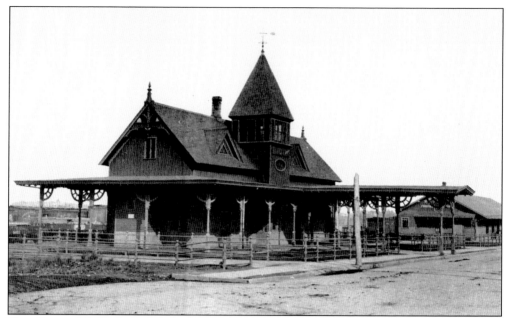

This Erie and Wyoming Valley Railroad passenger station was located on the 700 block of North Washington Avenue, several blocks north of downtown Scranton. To the right of the wooden depot is the company's freight house. The Erie and Wyoming Valley was the only major railroad to serve Scranton that did not have a station along Lackawanna Avenue. (Lackawanna Historical Society collection.)

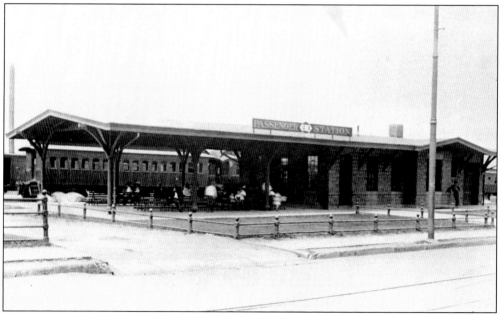

The simple wooden station constructed by the Erie and Wyoming Valley was replaced by this building in 1908. By this time, the Erie Railroad's ownership of the line is prominently displayed, and the original Erie and Wyoming Valley name has all but vanished. This building still survives, surrounded by the Coopers Seafood House complex. (Lackawanna Historical Society collection.)

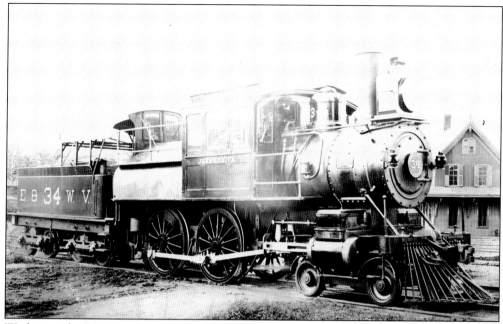

Workers at the Dunmore shops of the Erie and Wyoming Valley Railroad constructed a number of locomotives in the waning years of the 19th century. Engine No. 34, the *John B. Smith*, was an experimental three-cylinder locomotive designed for high-speed passenger service. Note the company's seldom-photographed Dunmore passenger station behind the locomotive. (Railroad Museum of Pennsylvania, Pennsylvania Historical and Museum Commission, reprinted with permission.)

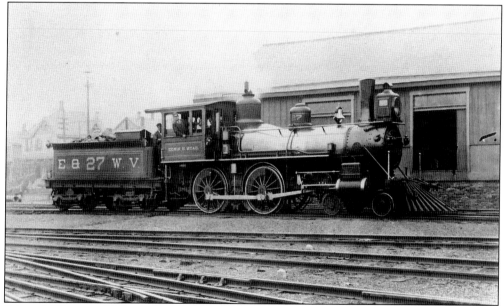

Erie and Wyoming Valley Railroad No. 27, the *Edwin H. Mead*, pauses in the Dunmore yard in this *c.* 1880 photograph. A typical late-19th-century locomotive, the engine was named in honor of the then president of the Pennsylvania Coal Company. (Railroad Museum of Pennsylvania, Pennsylvania Historical and Museum Commission, reprinted with permission.)

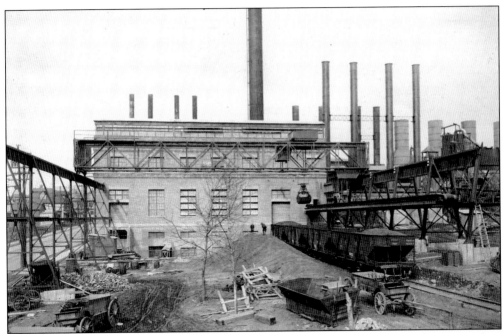

A ready supply of electricity was key to the industrial growth of Scranton and the surrounding area. Abundant quantities of fuel, in the form of anthracite coal, made the supply of electricity possible. Both the Delaware and Hudson and Erie Railroads delivered coal to the Scranton Electric Company, seen here around 1899. (Lackawanna Historical Society collection.)

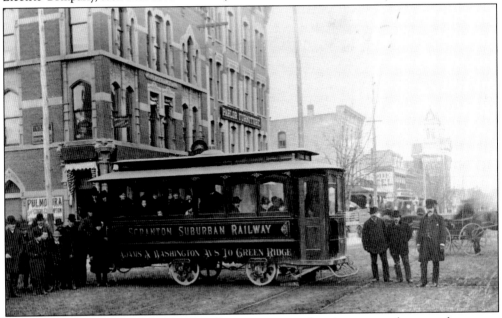

In 1886, the Scranton Suburban Railway began operating electric streetcars between downtown Scranton and the city's Green Ridge neighborhood. As the first commercially operated streetcar system in the nation, this operation helped Scranton earn the nickname "the Electric City." This 1886 photograph shows the original electric car at the intersection of Wyoming Avenue and Spruce Street. (Lackawanna Historical Society collection.)

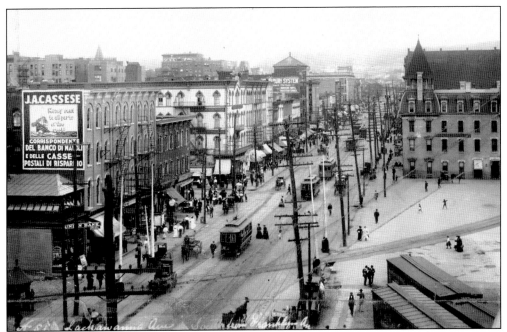

As seen here in 1895, Scranton was indeed a thriving metropolitan center. This image was taken from the roof of the Delaware, Lackawanna and Western Railroad's Scranton station, looking east along Lackawanna Avenue. In the foreground are the station's team tracks, used for unloading freight cars. (Lackawanna Historical Society collection.)

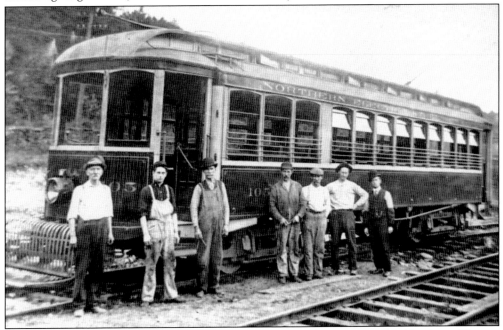

While Scranton's streetcar system primarily served its urban center, the Northern Electric Railway connected the city with outlying towns and farms to the north. In addition to providing passenger service, the line served as a daily supply line of fresh milk from the rural farmlands into Scranton until it ceased operations in 1932. (Lackawanna Historical Society collection.)

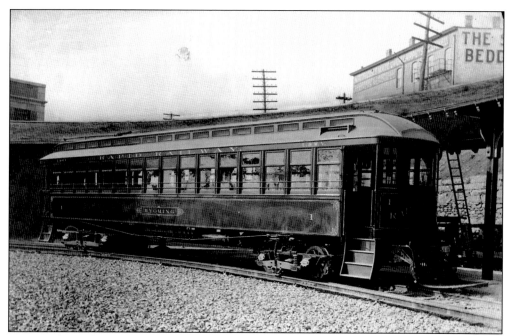

In 1902, the Lackawanna and Wyoming Valley Railroad began operation of a third-rail electric system more commonly known as the Laurel Line that connected the cities of Scranton and Wilkes-Barre. In this 1903 photograph, an early wooden passenger car waits at Scranton's circular station platform. (Lackawanna Historical Society collection.)

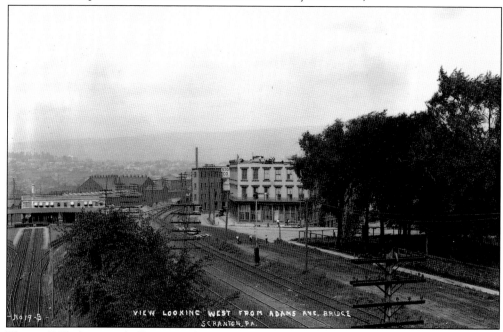

This c. 1903 photograph illustrates the proximity of the Laurel Line's Scranton terminal to the main line of the Delaware, Lackawanna and Western Railroad. In a few short years, this scene drastically changed with the construction of the railroad's new passenger station in the wooded area to the right. (Syracuse University Library collection.)

The Scranton passenger station for the Lackawanna and Wyoming Valley is seen shortly after its completion in this 1902 image. In a somewhat unusual twist, the city street is still a dirt road, yet the station's parking lot is paved. (Railroad Museum of Pennsylvania, Pennsylvania Historical and Museum Commission, reprinted with permission.)

In addition to its thriving passenger business, the Lackawanna and Wyoming Valley was also a common carrier freight railroad. This brick freight house was located next to the line's passenger station on Cedar Avenue in Scranton. Remarkably, this structure still exists, in somewhat modified form, as a commercial warehouse. (Railroad Museum of Pennsylvania, Pennsylvania Historical and Museum Commission, reprinted with permission.)

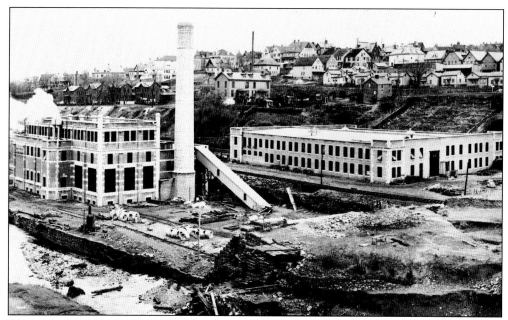

The Lackawanna and Wyoming Valley Railroad's powerhouse was constructed on land formerly occupied by the Lackawanna Iron and Steel Company. This view, looking west from the Harrison Avenue bridge, shows the newly completed facility with Scranton's Ridge Row neighborhood in the background. (Railroad Museum of Pennsylvania, Pennsylvania Historical and Museum Commission, reprinted with permission.)

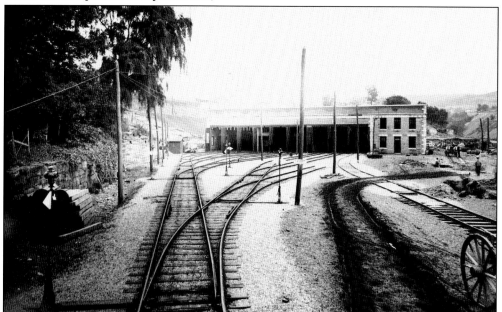

Because the presence of a ground-level electrified rail was deemed an unacceptable hazard for workers, certain areas such as the Scranton car shops were equipped with overhead trolley wire for powering the electric cars. This view is looking east toward the car shop, portions of which still exist as a manufacturing site. (Railroad Museum of Pennsylvania, Pennsylvania Historical and Museum Commission, reprinted with permission.)

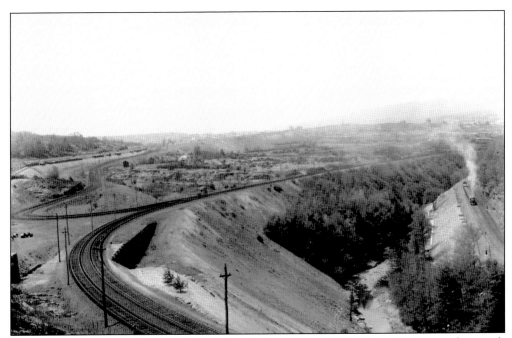

The original "Over the Hill" main line of the Lackawanna and Wyoming Valley stretches south toward Wilkes-Barre away from the photographer in this *c.* 1906 photograph. The set of tracks in the foreground is the company's Dunmore branch. Today the Central Scranton Expressway and Interstate 81 occupy much of this scene. (Lackawanna Historical Society collection.)

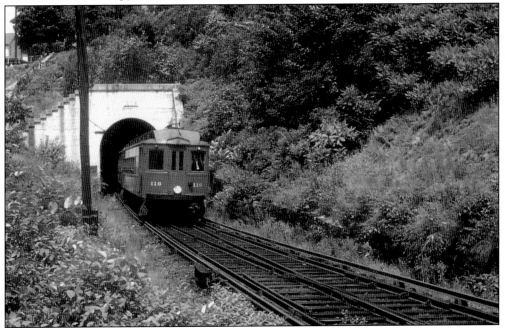

In 1905, the Laurel Line opened a nearly mile-long tunnel under Scranton's South Side neighborhood. In this *c.* 1940s image, a car exits the south portal of the tunnel under Crown Avenue. Eventually most of the company's traffic would be run through the tunnel and away from its original circuitous route out of the city. (Edward S. Miller photograph.)

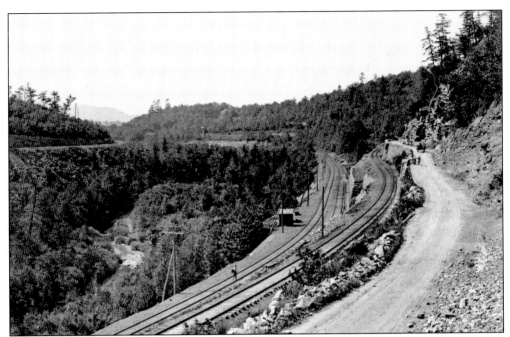

The Delaware, Lackawanna and Western Railroad's Winton branch was constructed in 1874 to serve several coal mines in the vicinity of Jessup. As seen in this c. 1900 photograph, the branch climbs steeply away from the main line along rock ledges, illustrating the lengths railroads went through to harvest anthracite coal. (Lackawanna Historical Society collection.)

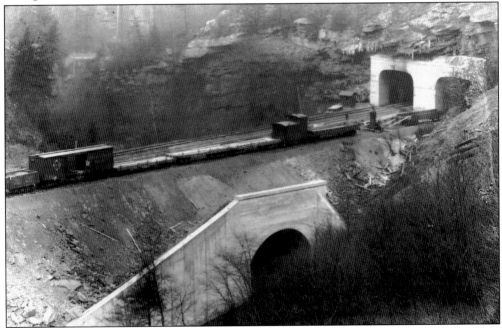

In this 1905 image, laborers are putting the finishing touches on an expanded Nay Aug tunnel. A second bore, closer to the photographer, was added by the Delaware, Lackawanna and Western to increase the line's capacity and allow slow-moving coal trains to leave the city without delaying faster traffic. (Steamtown National Historic Site collection.)

Three

LIFE ALONG
THE RAILROAD

As the railroad and coal concerns continued to spur Scranton's development into an industrial center, other industries took notice. Attracted by relatively inexpensive labor, readily available electricity from coal-fired power plants, and a means to transport their wares to market, the textile industry began to take root in Scranton. By the 1920s, there were nearly 50 silk mills operating in Scranton, illustrating the fact that coal was certainly not the city's lone export.

For hundreds of thousands of Lackawanna Valley residents, the railroad was part of their daily routine. In many cases, tracks were quite literally in one's own backyard. The train station became a casual gathering place and an important part of the local social scene. Many happy reunions began with a trip to the local depot to pick up relatives visiting from far away. Boarding the train could be an exciting start to a vacation or simply a ride home from work.

Farmers delivered fresh milk to countless country stations for urban consumers. Likewise, fresh produce arrived by the carload to be distributed to customers in Scranton's wholesale district. Rail was the preferred method of delivery for United States mail for nearly 100 years, while the Railway Express Agency handled larger packages, catalog orders, and the like. One could even order a "Sears Modern Home," to be delivered by rail to the closest siding available.

In 1886, Scranton inaugurated service on the first commercial electric streetcar system in America, earning Scranton the nickname the Electric City. In 1902, the Lackawanna and Wyoming Valley Railroad began offering high-speed transit and freight service southward to the cities of Pittston and Wilkes-Barre, while the Northern Electric Railway served outlying towns to the north, completing Scranton's transportation network.

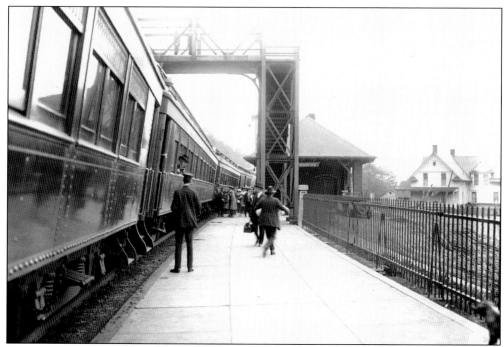

In a scene from the glory days of rail travel, men and women board a train at Moscow. The overhead walkway and banked curve upon which the train sits indicate this was high-speed territory and passengers best keep off the tracks. (Steamtown National Historic Site collection.)

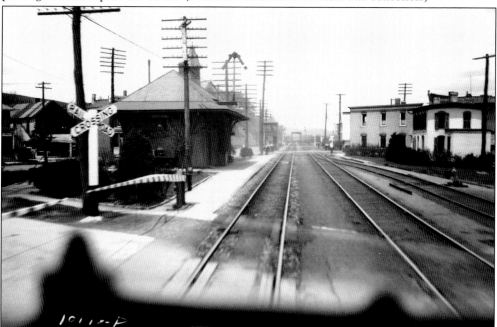

The typical small-town depot is spotted from the back of an Erie Railroad train in Avoca. Note the ornate railings in the foreground, allowing for the possibility that this photograph was taken from a railroad-owned business car on a special run. (Railroad Museum of Pennsylvania, Pennsylvania Historical and Museum Commission, reprinted with permission.)

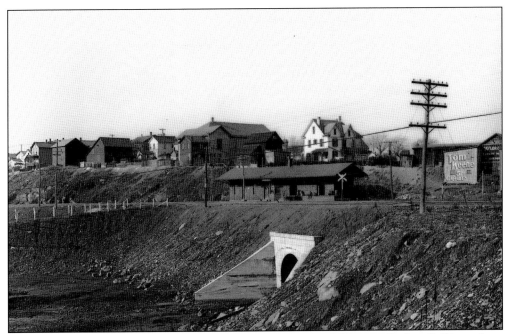

The simple wooden depot on the Delaware, Lackawanna and Western Railroad's Bloomsburg branch at Taylor typified the small-town passenger station of 1910. This station was eventually replaced by a brick structure that stands to this day. (Steamtown National Historic Site collection.)

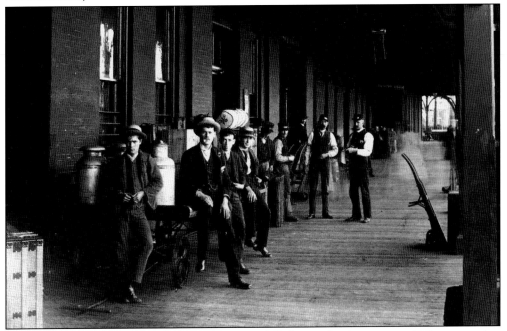

There is quite a crowd on the platform of Scranton's Delaware, Lackawanna and Western station in this c. 1895 view. Local merchants and laborers pose with goods that have most likely just been delivered by train as railroad employees in black vests survey the scene. (Railroad Museum of Pennsylvania, Pennsylvania Historical Museum Commission, reprinted with permission.)

Before air travel, the railroad was the quickest way to send parcels, and the United States Express Company was one of the first companies to handle this method of shipping. The company's platform was located at the west end of the Delaware, Lackawanna and Western Railroad's Scranton station. (Railroad Museum of Pennsylvania, Pennsylvania Historical and Museum Commission, reprinted with permission.)

There is plenty of activity in Scranton's wholesale district on this day. Here local merchants arrive to pick up perishable items such as vegetables and groceries on team tracks adjacent to the Delaware, Lackawanna and Western's original Scranton station. This location is now the parking area for Scranton's state office building. (Syracuse University Library collection.)

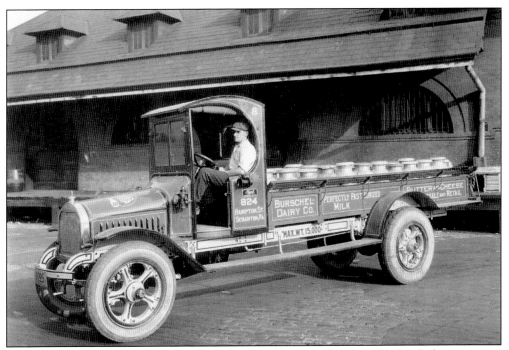

Fresh milk was an important commodity transported by the railroads in the days before interstate highways and mechanical refrigeration. As seen here, fresh milk has been loaded onto a Burschel Dairy truck at the Central Railroad of New Jersey freight station in Scranton. (Lackawanna Historical Society collection.)

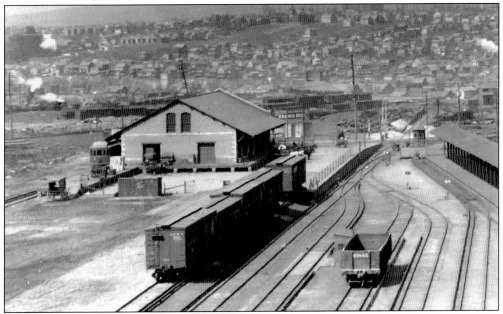

The Laurel Line freight house is full of activity in this 1905 image. In the foreground is the interchange yard with the Delaware, Lackawanna and Western. On the left side of the depot, one of the company's three express freight motors sits at the platform. (Lackawanna Historical Society collection.)

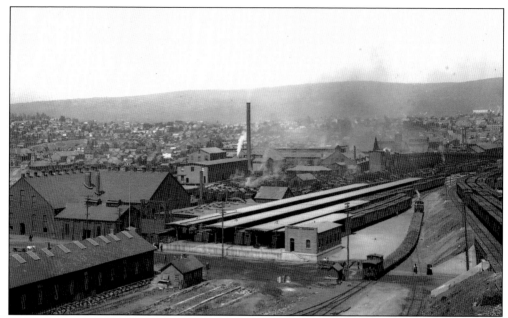

The Delaware, Lackawanna and Western Railroad's less-than-carload lot (LCL) facility is seen here in 1907. Handling smaller shipments from different customers in the same boxcar was labor-intensive yet provided a significant source of revenue for many railroads. At this time, the railroad has yet to begin construction of its new erecting shops along Washington Avenue. (Syracuse University Library collection.)

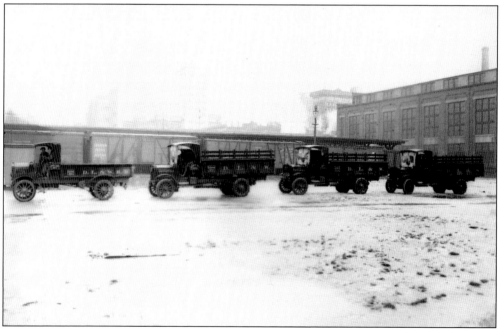

Delaware, Lackawanna and Western stores department trucks are lined up at the railroad's LCL transfer facility around 1915. Today this site is the headquarters for the Scranton Police Department. (Railroad Museum of Pennsylvania, Pennsylvania Historical and Museum Commission, reprinted with permission.)

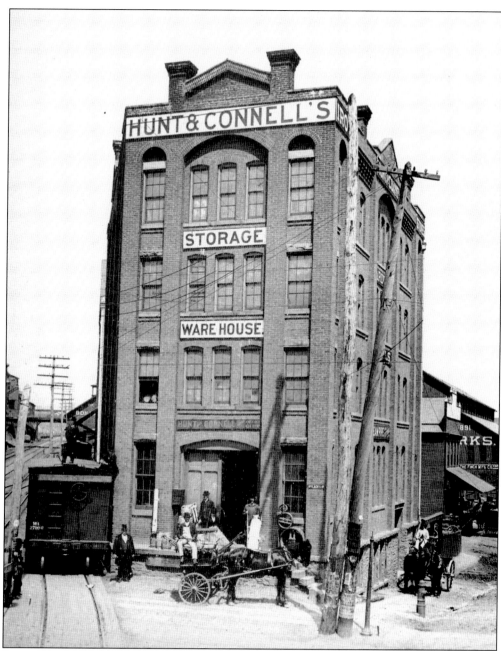

Privately owned warehouses were once common fixtures along the railroad. The Hunt and Connell warehouse was located at the intersection of Lackawanna and Eighth Avenues in downtown Scranton. The location of this building allowed for the efficient transfer of items from the railroad to merchant-owned wagons. The Delaware, Lackawanna and Western's main line is visible on the left of this 1895 photograph. (Lackawanna Historical Society collection.)

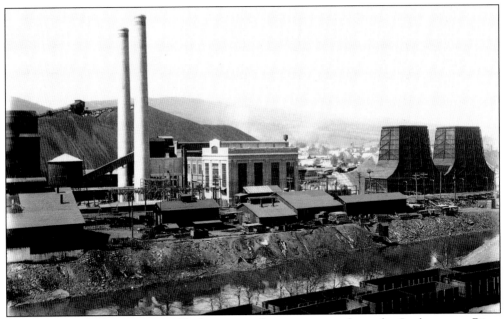

The Hudson Coal Company's Olyphant powerhouse is seen along the Lackawanna River in 1922. Electricity generated at sites like this was supplied to not only company-owned facilities but commercial enterprises as well. In the foreground is the Delaware and Hudson Railroad. (Pennsylvania Anthracite Heritage Museum, Pennsylvania Historical and Museum Commission.)

High-tension power lines carry electricity along the tracks of the Delaware and Hudson Railroad at the Marvine colliery near the city limits in North Scranton. Readily available electricity was one of the primary factors that lured the other industries to the area. (Pennsylvania Anthracite Heritage Museum, Pennsylvania Historical and Museum Commission.)

In 1855, Thomas Dickson founded the Dickson Manufacturing Company. Products eventually offered by the firm included boilers, cable machinery, and complete locomotives. The general offices of the company are seen here around 1890. While the building in the foreground was razed decades ago, the building to the rear still stands and is featured in the opening sequence of the television show *The Office*. (Lackawanna Historical Society collection.)

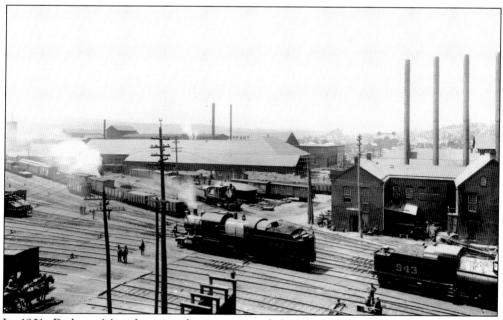

In 1901, Dickson Manufacturing became part of the newly formed American Locomotive Company (ALCO). This 1902 image shows the former Dickson facility as operated by ALCO adjacent to the Delaware Lackawanna and Western Railroad's downtown yard. ALCO ceased operation of its Dickson works in 1909. (Lackawanna Historical Society collection.)

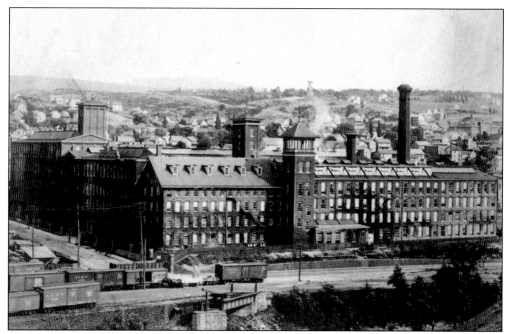

The textile industry was attracted to Scranton by abundant electricity, cheap labor, and an extensive transportation system. By 1920, over 40 silk mills were operating in the city. One of the earliest of these was the Sauquoit Mill, constructed along the Delaware and Hudson Railroad at South Washington Avenue in 1879. (Lackawanna Historical Society collection.)

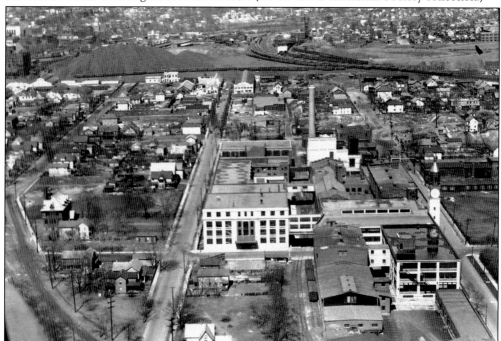

The Scranton Lace Curtain Company was a sprawling enterprise north of downtown Scranton that was served by two railroads: the Delaware and Hudson and the Delaware, Lackawanna and Western Railroad via its Green Ridge branch. (Lackawanna Historical Society collection.)

The small village of Nay Aug and its namesake brick works were located just east of Scranton as viewed from the Delaware, Lackawanna and Western Railroad main line in 1908. To serve this plant, the railroad crossed Roaring Brook on a small bridge, behind the trees to the left of the photographer. Today nothing remains of the village. (Steamtown National Historic Site collection.)

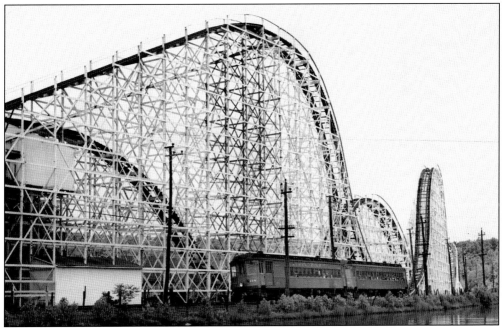

A popular leisure destination along the Laurel Line was the Rocky Glen amusement park. A two-car passenger train is seen passing the park's "Million Dollar Coaster" in this photograph. Rocky Glen Park outlasted the railroad by several decades, closing in the late 1980s. (Lackawanna Historical Society collection, Edward S. Miller photograph.)

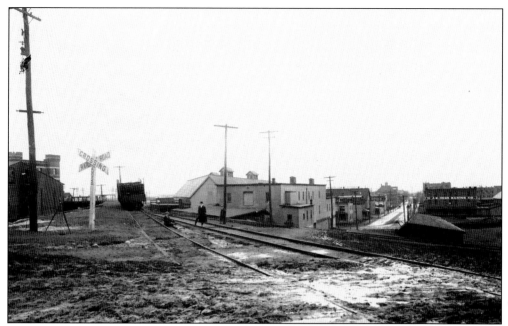

An Erie Railroad survey crew pauses at the Ash Street grade crossing in this 1912 photograph. This dirt and mud thoroughfare was typical of Scranton's roads at the time. This view is looking south toward the line's Scranton terminus. According to the photographer's notes, the surveying work was being done in anticipation of future improvements at the site. (Lackawanna Historical Society collection.)

Manual crossing gates guard the tracks of the Delaware, Lackawanna and Western Railroad's Bloomsburg branch in this 1911 scene looking east along Scranton Street. Beyond the crossing is the steel girder bridge that carried the Central Railroad of New Jersey over this busy thoroughfare. (Syracuse University Library collection.)

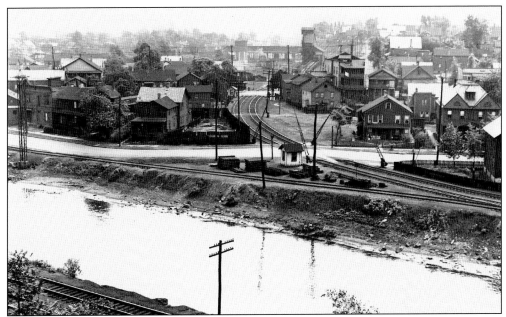

The Central Railroad of New Jersey Scranton division roundhouse and main line are seen nestled in an otherwise quiet south Scranton neighborhood. This view is from the Delaware, Lackawanna and Western's city yard looking south over the Lackawanna River. In the foreground are the tracks belonging to the Delaware and Hudson Railroad. (Railroad Avenue Enterprises photograph.)

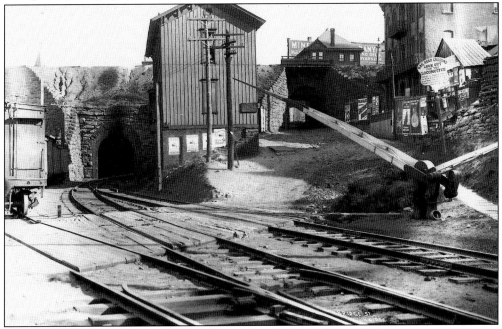

The Delaware and Hudson's single-track tunnel under the Delaware, Lackawanna and Western in downtown Scranton proved a constant bottleneck on the busy line. This view at Cliff Street illustrates how several tracks came together to pass through the tunnel. (Syracuse University Library collection.)

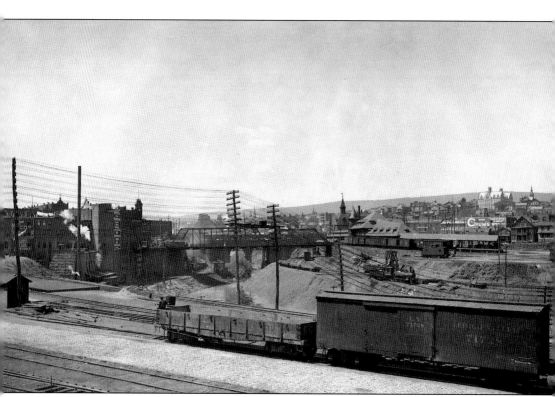

Four separate railroads are visible in this c. 1905 photograph from the Linden Street bridge. In the lower left corner is the Delaware, Lackawanna and Western Railroad's diamond branch. On the other side of the brick street are the tracks that led up to the rear of the Delaware and Hudson's passenger station. Across the river both Central Railroad of New Jersey and New York, Ontario and Western Railway equipment mingles in the interchange yard of the two companies. (Lackawanna Historical Society collection.)

Four

A MASSIVE INFRASTRUCTURE

Steam locomotives, being incredibly maintenance-intensive machines, required large servicing facilities and scores of workers to service them. Each railroad had its own locomotive servicing and repair centers to support its operations. Most of these facilities featured roundhouses, circular buildings designed specifically to house and maintain these machines. Railroads were second only to the coal industry in the number of those on the payroll. Every aspect of running a railroad required specialized labor, from locomotive engineers to yard clerks, from machinists to dining car attendants.

The Delaware, Lackawanna and Western Railroad came to have the most visible presence of all the railroads serving Scranton. The company also built a roundhouse at the Hampton yard and a vast car repair shop at its Keyser Valley yard, as well as several other yards for the handling of freight trains entering and leaving the area. In 1908, the Delaware, Lackawanna and Western completed a massive station and office building several blocks to the east of its original 19th-century depot.

Less than a mile away from the Delaware, Lackawanna and Western's facilities in downtown Scranton, the Central Railroad of New Jersey built its roundhouse and yard in the city's South Side. The Erie Railroad constructed a roundhouse as well as an immense car shop just outside the city limits in the town of Dunmore. The Delaware and Hudson Railroad and the New York, Ontario and Western Railway chose to locate their facilities north of Scranton along the Lackawanna River in the towns of Carbondale and Mayfield, respectively.

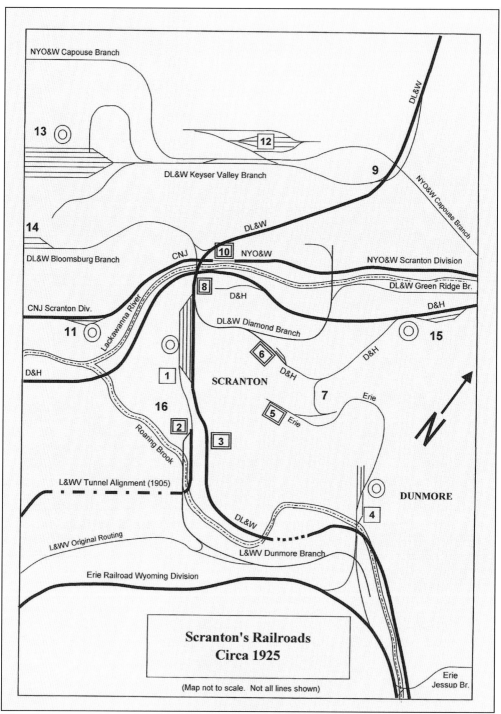

This illustration depicts the network of rail lines present in Scranton during the 1920s. Thick lines depict main line tracks while the numerous branch lines and rail yards are shown as thin lines. (David Crosby illustration.)

Some of Scranton's more significant industrial sites and railroad yards numbered on the map to the left are identified here. Not all branch lines are shown. (David Crosby illustration.)

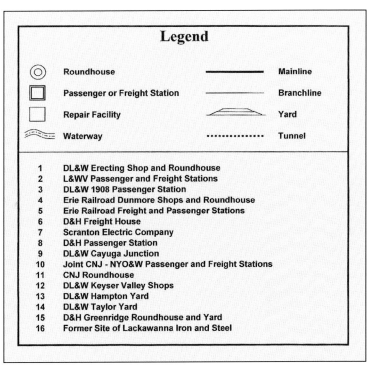

Legend

◎	Roundhouse	———	Mainline
▣	Passenger or Freight Station	——	Branchline
▢	Repair Facility	▱	Yard
〰	Waterway	··········	Tunnel

1	DL&W Erecting Shop and Roundhouse
2	L&WV Passenger and Freight Stations
3	DL&W 1908 Passenger Station
4	Erie Railroad Dunmore Shops and Roundhouse
5	Erie Railroad Freight and Passenger Stations
6	D&H Freight House
7	Scranton Electric Company
8	D&H Passenger Station
9	DL&W Cayuga Junction
10	Joint CNJ - NYO&W Passenger and Freight Stations
11	CNJ Roundhouse
12	DL&W Keyser Valley Shops
13	DL&W Hampton Yard
14	DL&W Taylor Yard
15	D&H Greenridge Roundhouse and Yard
16	Former Site of Lackawanna Iron and Steel

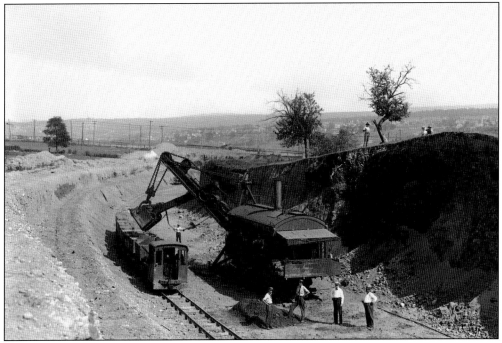

In 1911, the Delaware, Lackawanna and Western Railroad construction crews work to complete a bypass of sorts between the company's Hampton and Taylor yards. In this scene, a steam shovel is loading debris into narrow-gauge cars, material that will then be used as landfill in other locations. (Railroad Museum of Pennsylvania, Pennsylvania Historical and Museum Commission, reprinted with permission.)

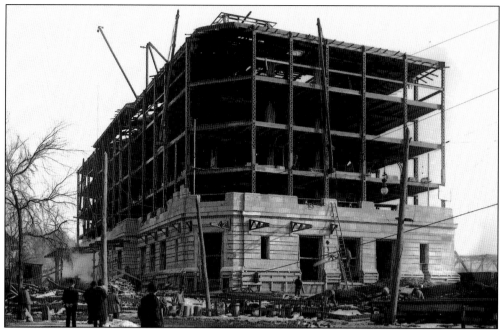

In 1907, the Delaware, Lackawanna and Western Railroad began construction of a massive new passenger station and office building at the intersection of Lackawanna and Jefferson Avenues in Scranton. By the time this photograph was taken, the building's steel superstructure was in place and a limestone facade was being applied. (Syracuse University Library collection.)

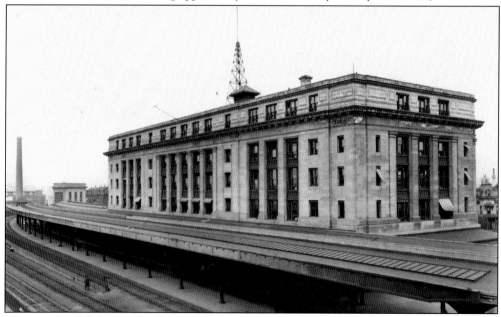

The completed Delaware, Lackawanna and Western station is seen here around 1914. Note the large radio antenna atop the building, constructed as part of a 1913 test of radio communications with moving trains conducted by the Marconi Radio Company and the railroad. (Railroad Museum of Pennsylvania, Pennsylvania Historical and Museum Commission, reprinted with permission.)

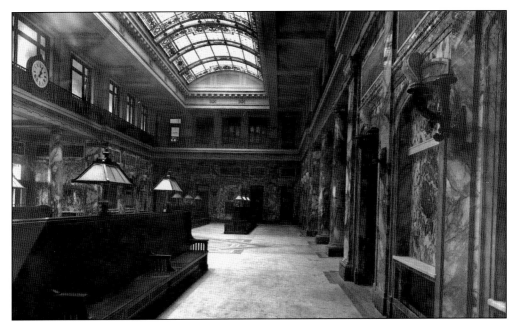

When the Delaware, Lackawanna and Western set about building its new passenger station in Scranton, the intent was to convey a sense of grandeur and elegance to the traveling public. To that end, the main waiting room was appointed with several different varieties of marble and featured a vaulted stained-glass ceiling. (Railroad Museum of Pennsylvania, Pennsylvania Historical and Museum Commission, reprinted with permission.)

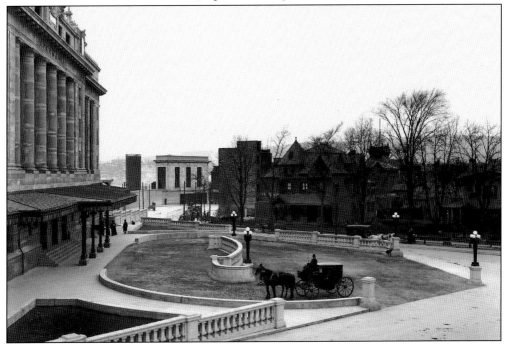

A horse and carriage awaits its charge in front of the newly completed passenger station in 1908. By this time, an impressive urban infrastructure is in place, complete with paved streets, electric lamps, and power poles for the city's streetcar system. (Syracuse University Library collection.)

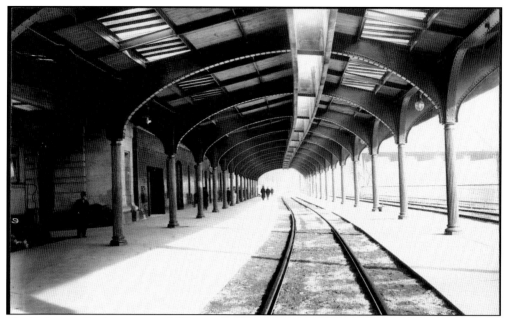

The Delaware, Lackawanna and Western Railroad designed enclosed platforms to be part of its new station. These "train sheds," as they were called, allowed smoke from the steam locomotives to dissipate through an overhead channel in the ceiling while at the same time keeping platforms dry during inclement weather. (Railroad Museum of Pennsylvania, Pennsylvania Historical and Museum Commission, reprinted with permission.)

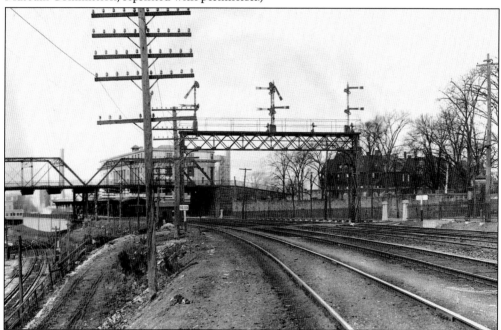

Scranton's iconic Spruce Street bridge dominates this c. 1910 photograph along the Delaware, Lackawanna and Western. Through the trees on the right is the Scranton estate, onetime residence of the influential family of iron makers. (Railroad Museum of Pennsylvania, Pennsylvania Historical and Museum Commission, reprinted with permission.)

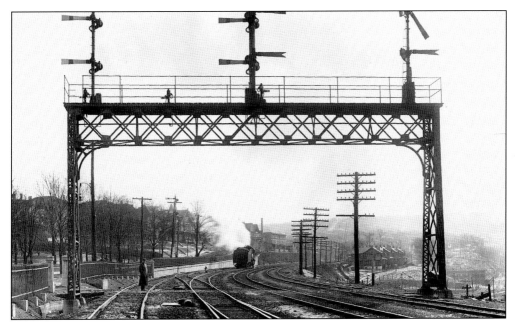

Scranton's Ridge Row is seen in this east-facing view from the Delaware, Lackawanna and Western passenger station. In the distance, to the right of the tracks, are former company housing units for the Lackawanna Iron and Steel Company. In the foreground are devices known as semaphores, which controlled train traffic along the railroad at the time. (Railroad Museum of Pennsylvania, Pennsylvania Historical and Museum Commission, reprinted with permission.)

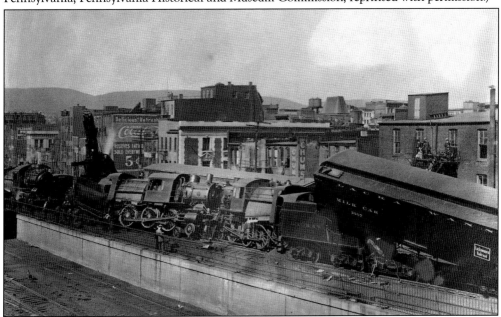

Despite the many safety advances brought to the railroads in the early 20th century, no amount of technology could eliminate the specter of human error. In this scene, two trains have collided near the west end of the Delaware, Lackawanna and Western passenger station, the result of a failure by one of the trains to stop where directed. (Railroad Museum of Pennsylvania, Pennsylvania Historical and Museum Commission, reprinted with permission.)

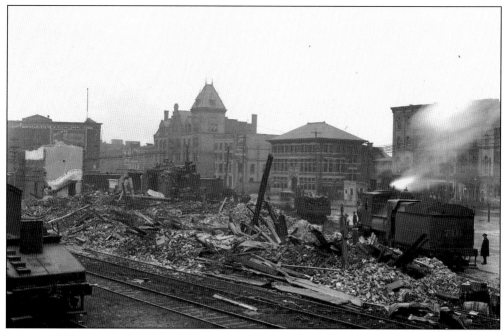

Upon completion of the new passenger facility, the Delaware, Lackawanna and Western Railroad razed its antiquated 1864 station, located six blocks to the west. Final demolition is taking place during March 1909 in this view, looking west toward the Delaware and Hudson Railroad's station on Lackawanna Avenue. (Syracuse University Library collection.)

This rather utilitarian freight house was constructed on the site of the original Delaware, Lackawanna and Western passenger station. This facility lasted into the 1960s when it was razed to make way for Scranton State Office Building. This view of the building's north side was taken in August 1910 from Lackawanna Avenue. (Syracuse University Library collection.)

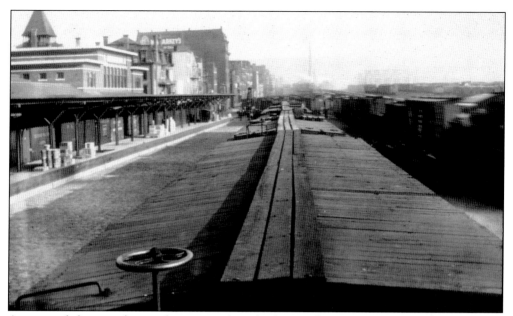

An intrepid photographer was brave enough to climb atop a boxcar to capture this unique image. To the left of the train is the Delaware, Lackawanna and Western's Scranton freight house. Note the vertical brake wheels on each car, used to set manual breaks on the cars when they were not connected to a train. (Steamtown National Historic Site collection.)

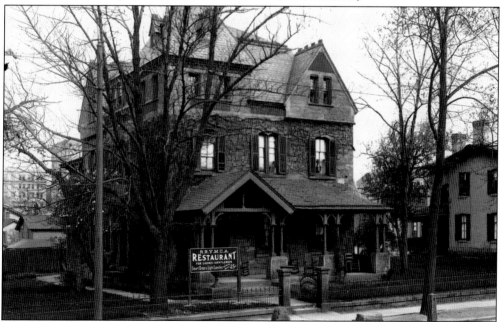

Railroad YMCAs were founded in many cities to see to the physical and spiritual needs of the railroad worker. They often provided medical care and lodging at rates the average laborer could not otherwise afford. Scranton's railroad YMCA was located across the street from the Delaware, Lackawanna and Western's new passenger station and featured a lunchroom with complete meals for a reasonable price. (Railroad Museum of Pennsylvania, Pennsylvania Historical and Museum Commission, reprinted with permission.)

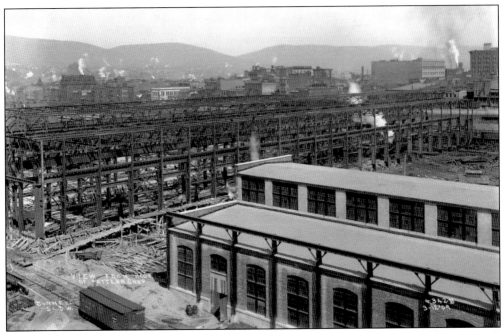

Construction of the Delaware, Lackawanna and Western Railroad's erecting shops is well underway in this 1909 photograph. Construction of this facility took place during a period of prosperity that saw extensive improvements made to the physical plant of the railroad. (Syracuse University Library collection.)

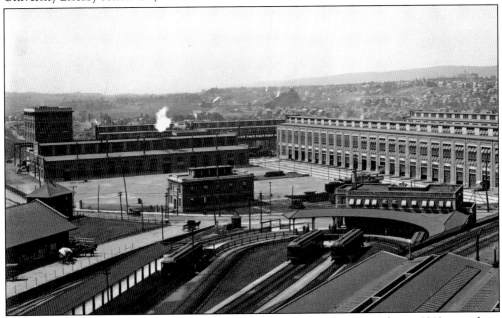

The new Delaware, Lackawanna and Western erecting shops dominate this *c.* 1910 view from the roof of the company's passenger station. In the foreground are the station's train sheds with their smoke vents. In the middle of the photograph is the Scranton station of the Lackawanna and Wyoming Valley Railroad. (Railroad Museum of Pennsylvania, Pennsylvania Historical and Museum Commission, reprinted with permission.)

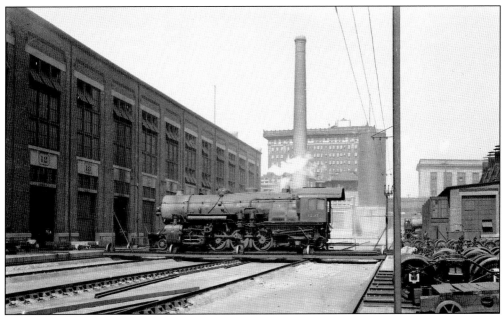

A large transfer table was constructed to facilitate movement of locomotives between different sections of the erecting shop. Similar to a turntable, this bridge on wheels moved sideways and could line up with any number of tracks leading into the building. In this 1920 scene, 2-8-2 No. 1237 is positioned for movement into the shop. (Railroad Museum of Pennsylvania, Pennsylvania Historical and Museum Commission, reprinted with permission.)

To connect the network of railroad-owned buildings in downtown Scranton, the Delaware, Lackawanna and Western constructed a battery-powered underground railway. This system enabled supplies to be moved quickly between buildings regardless of conditions on the streets above. (Railroad Museum of Pennsylvania, Pennsylvania Historical and Museum Commission, reprinted with permission.)

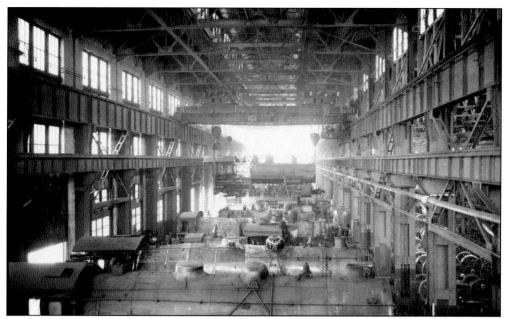

Once inside the main building, locomotives in whole or in part could be moved from one area to another by means of an overhead crane. The crane could also move engines into areas of the building not accessible by tracks on the outside, creating more room to work. As seen in this *c.* 1920 photograph, work space was certainly at a premium. (Railroad Museum of Pennsylvania, Pennsylvania Historical and Museum Commission, reprinted with permission.)

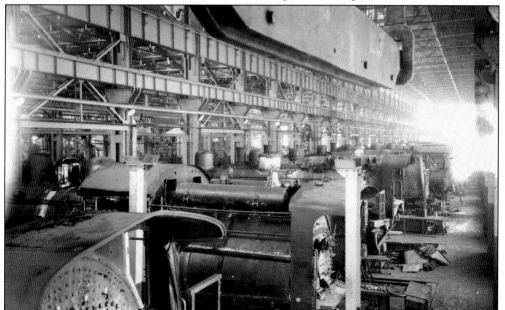

In this scene, a number of camelback-type locomotives are lined up for work. During the 1920s, the Delaware, Lackawanna and Western Railroad embarked on a program to convert the camelbacks into conventional end-cab locomotives, and it is thought that is the task being performed here. (Railroad Museum of Pennsylvania, Pennsylvania Historical and Museum Commission, reprinted with permission.)

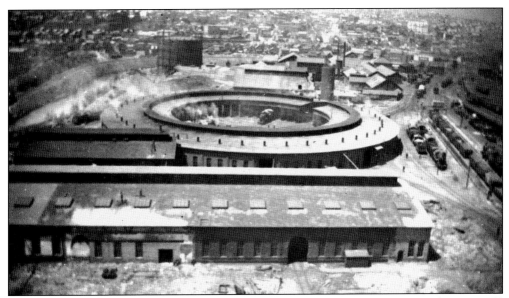

At the beginning of the 20th century, the Delaware, Lackawanna and Western tore down its 1855 and 1865 roundhouses. In 1902, the company completed a newer, larger roundhouse on the site of the 1865 structure. The original 1865 locomotive shops were also modified in the years following the construction of the new roundhouse, as seen in this *c.* 1908 image. (Railroad Museum of Pennsylvania, Pennsylvania Historical and Museum Commission, reprinted with permission.)

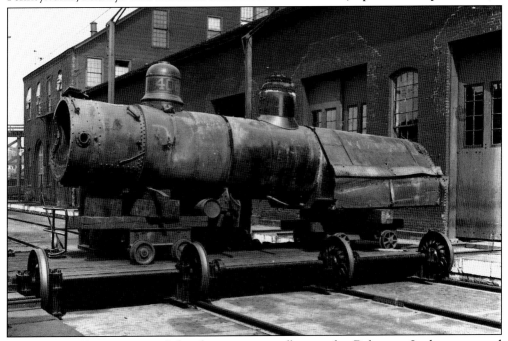

Prior to a 1937 expansion of the downtown roundhouse, the Delaware, Lackawanna and Western made use of a small transfer table. This table was located between the modified 1865-era locomotive shop and the 1902 roundhouse. Here a locomotive boiler with apparent wreck damage is positioned on work dollies between the two buildings. (Railroad Museum of Pennsylvania, Pennsylvania Historical and Museum Commission, reprinted with permission.)

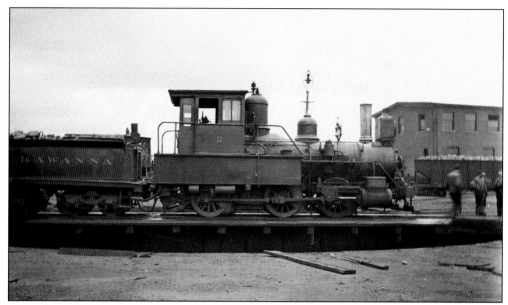

Even after the Delaware, Lackawanna and Western Railroad's original 1855 roundhouse was rendered obsolete by locomotives too large to be serviced there, its turntable would remain in operation. In this 1910 photograph, an ancient locomotive modified for switching duties moves a tender across the table. In time, this 65-foot-long turntable was replaced by a 90-foot version. (Railroad Museum of Pennsylvania, Pennsylvania Historical and Museum Commission, reprinted with permission.)

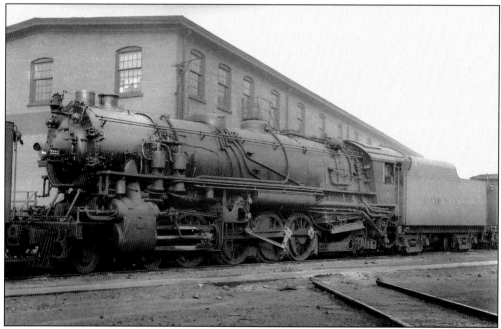

In the 1920s, railroads embraced so-called superpower steam engines that represented the state of the art in locomotive construction at the time. Comparing engine No. 2225, built in 1926, to locomotives of the previous century illustrates the need to construct larger buildings to maintain them. (Railroad Avenue Enterprises photograph.)

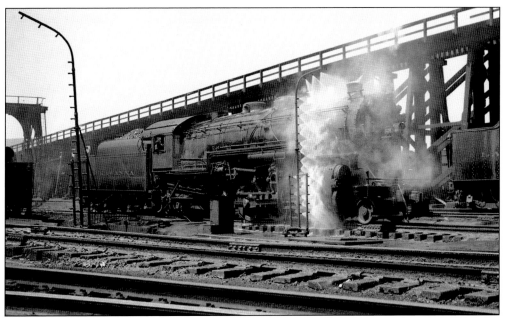

Railroads frequently washed their motive power as seen in this 1930 photograph. Cleaning a locomotive was done as much for mechanical reasons as it was for the railroad's image. Fine cinders and grit built up while on the road had the potential to damage many of the finely tuned moving parts on a locomotive, thus cleanliness was of the utmost importance. (Railroad Museum of Pennsylvania, Pennsylvania Historical and Museum Commission, reprinted with permission.)

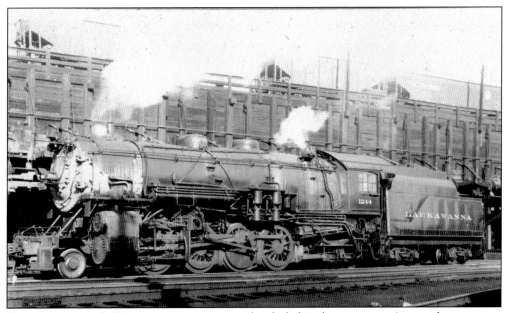

Coal not only fueled Scranton's economy, it also fueled its locomotives. As seen here, engine No. 1244 passes the line's massive coaling facility in the Delaware, Lackawanna and Western's downtown city yard. There are at least four hopper cars being dumped into the coal pockets in this photograph. (Steamtown National Historic Site collection.)

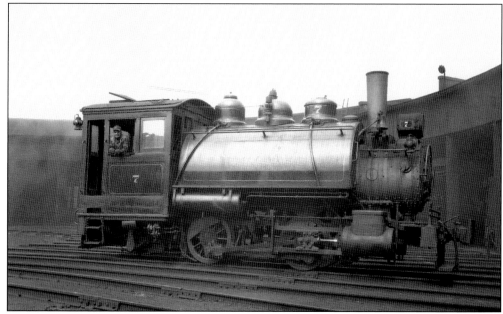

Diminutive locomotive No. 7 spent most, if not all, of its operating life in the Delaware, Lackawanna and Western Railroad's downtown city yard. This engine was used to move much larger locomotives around the roundhouse and shop complex while they were not under steam. (Railroad Museum of Pennsylvania, Pennsylvania Historical and Museum Commission, reprinted with permission.)

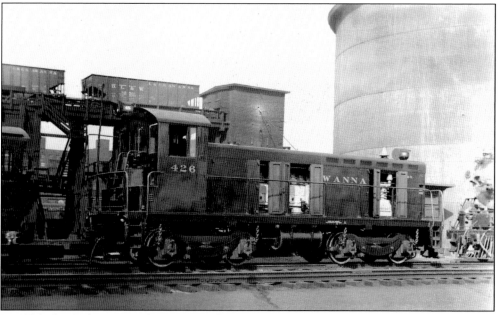

In 1935, the Delaware, Lackawanna and Western ordered two SC-class diesel locomotives from the Electro-Motive Corporation, later the Electro-Motive Division of General Motors. Locomotive No. 426, one of those pioneering units, represents the state of the art at the time. This locomotive survives to this day and is frequently on display at Steamtown National Historic Site. (Steamtown National Historic Site collection.)

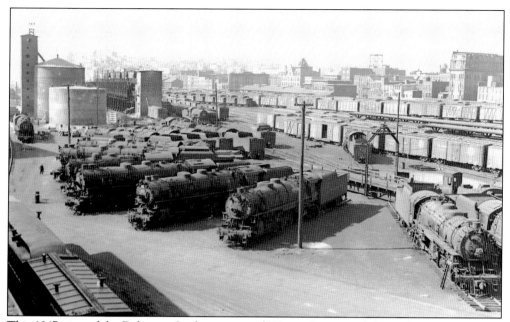

This 1947 view of the Delaware, Lackawanna and Western's city yard shows the area commonly referred to as "Hogtown," as railroad employees commonly referred to locomotives as "hogs." This location was the site of Scranton's first roundhouse and turntable, built in 1855 and razed around 1900. A larger turntable was then installed at this location prior to World War I. (Railroad Avenue Enterprises photograph.)

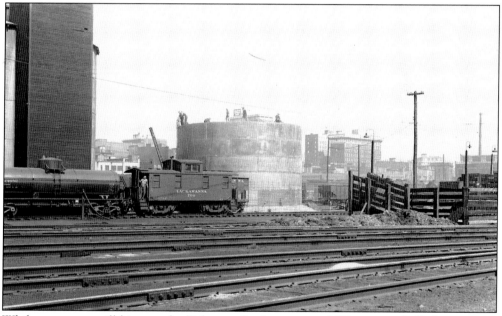

While steam was still king on the Delaware, Lackawanna and Western in 1947, the company was purchasing diesel locomotives as fast as it could afford to do so. In this scene, workers are constructing one of four large diesel fuel storage tanks put in place that year. Also of interest is the company's cattle pen, used to offload livestock cars, on the right-hand side of the photograph. (Railroad Avenue Enterprises photograph.)

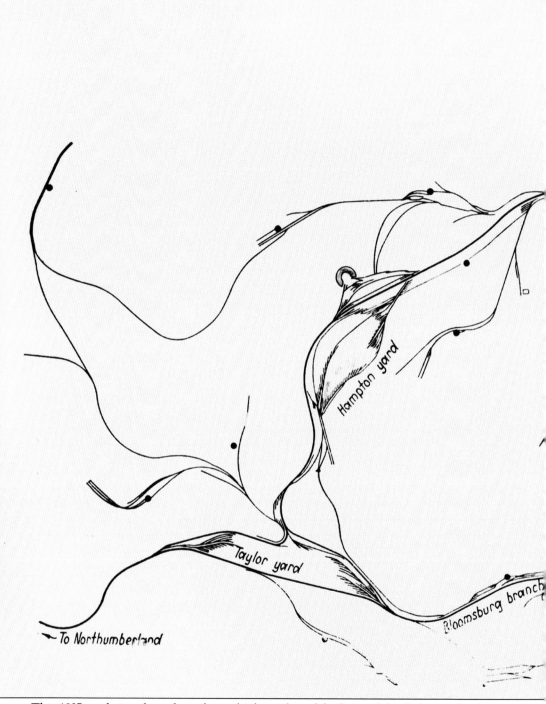

Hampton yard

Taylor yard

Bloomsburg branch

To Northumberland

This 1927 rendering shows how the multiple yards and facilities of the Delaware, Lackawanna and Western Railroad were connected. The Taylor yard and Hampton yard primarily handled coal traffic. Keyser Valley was a repair center for freight cars. The city yard, today's Steamtown

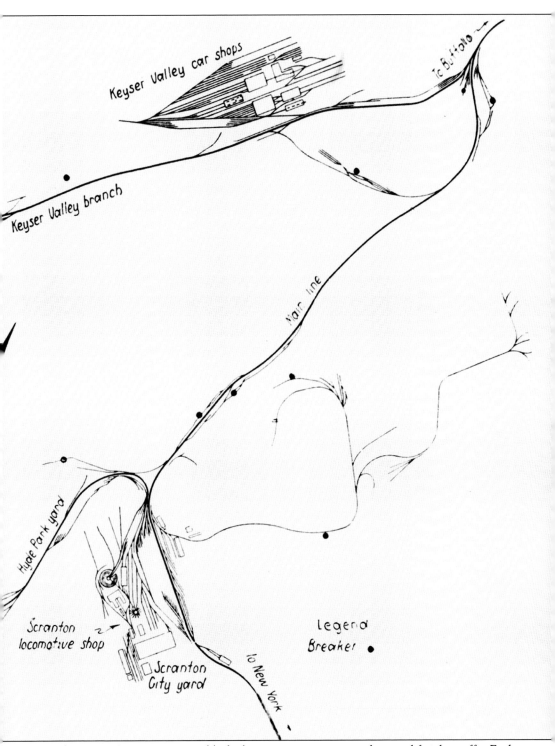

Keyser Valley car shops

To Buffalo

Keyser Valley branch

Main line

Hyde Park yard

Scranton
locomotive shop

Scranton
City yard

To New York

Legend
Breaker ●

National Historic Site, was responsible for locomotive servicing and general freight traffic. Each black dot represents a coal breaker operating at the time. (Railroad Museum of Pennsylvania, Pennsylvania Historical and Museum Commission, reprinted with permission.)

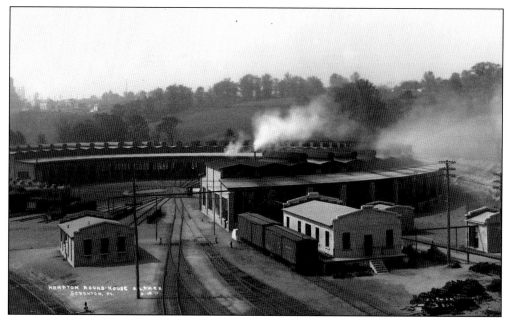

The Delaware, Lackawanna and Western Railroad's Hampton yard also had a large roundhouse that was used to service locomotives used on mine runs on the Bloomsburg branch. This 1911 photograph shows a tidy, well-maintained facility. Today very little remains of the Hampton yard. (Railroad Museum of Pennsylvania, Pennsylvania Historical and Museum Commission, reprinted with permission.)

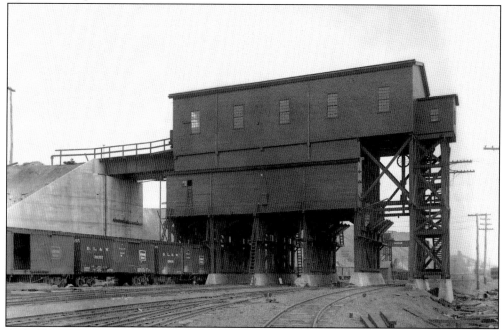

To fuel locomotives operating out of the Hampton yard, the railroad constructed a winding track, which ran up a hillside before doubling about 30 feet above the yard tracks. At this location coal would be dumped into the wooden coal pockets as seen here in 1911. (Railroad Museum of Pennsylvania, Pennsylvania Historical and Museum Commission, reprinted with permission.)

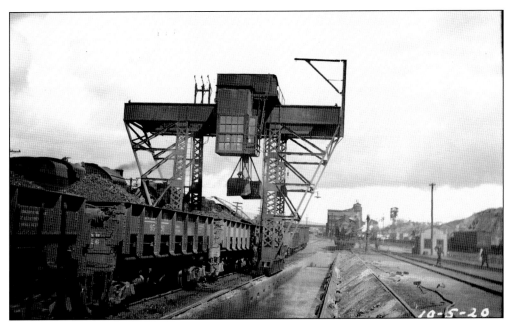

Cleaning and reclaiming ash from the fireboxes of coal-burning locomotives was a never-ending task. Before and after a day's work, locomotives were placed over sloped ash pits where the waste could be dumped from pans under the locomotive's firebox. In this 1920 view, several locomotives are waiting at the ash pit. (Railroad Museum of Pennsylvania, Pennsylvania Historical and Museum Commission, reprinted with permission.)

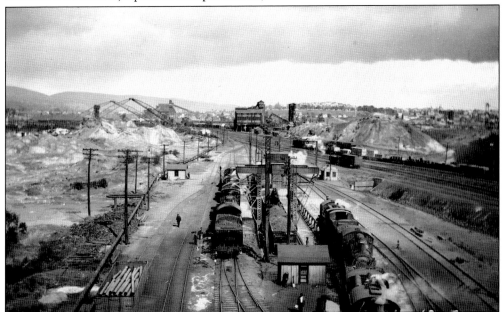

In this 1920 view, a locomotive has dumped ash and is moving away from the photographer. To collect the spent material, water was sprayed on the sloped section of the pit. The ash slurry then ran toward the center of the pit and was collected by an overhead clamshell derrick and dumped into waiting railroad cars. (Railroad Museum of Pennsylvania, Pennsylvania Historical and Museum Commission, reprinted with permission.)

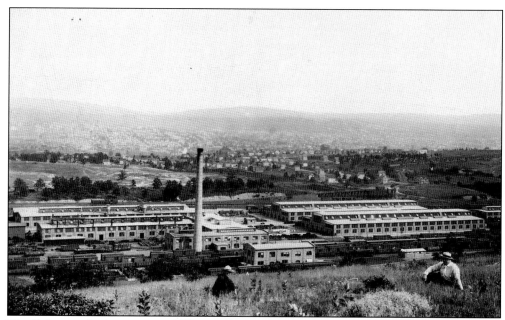

The Delaware, Lackawanna and Western Railroad's Keyser Valley shops are seen here in 1926 from a neighboring hillside. The Keyser Valley shops handled freight and passenger car repairs in several massive buildings. Today much of this complex is gone, save for a few buildings converted to other uses. (Railroad Museum of Pennsylvania, Pennsylvania Historical and Museum Commission, reprinted with permission.)

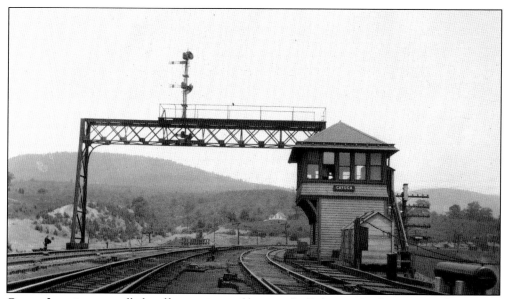

Cayuga Junction controlled traffic entering and leaving the Delaware, Lackawanna and Western's Keyser Valley branch with the wooden switch tower seen here. An operator in the tower manipulated levers to operate various switches through a series of interconnected rods, seen in the lower right corner of this photograph. (Railroad Museum of Pennsylvania, Pennsylvania Historical and Museum Commission, reprinted with permission.)

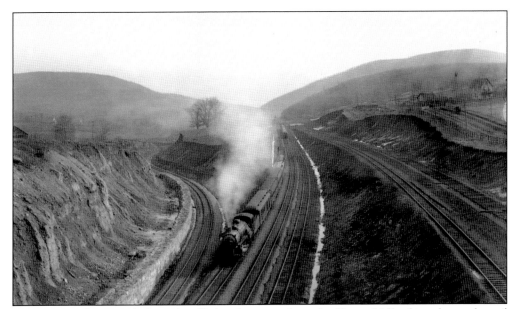

To maintain the smooth flow of traffic heading west from the Keyser Valley branch, westbound trains ran under the main line in an arrangement not unlike a highway acceleration ramp. This eliminated the need for the slow-moving trains to cross several active tracks at the junction itself. This view looking east shows a westbound passenger train accelerating with the Keyser Valley branch merging on the left. (Railroad Museum of Pennsylvania, Pennsylvania Historical and Museum Commission, reprinted with permission.)

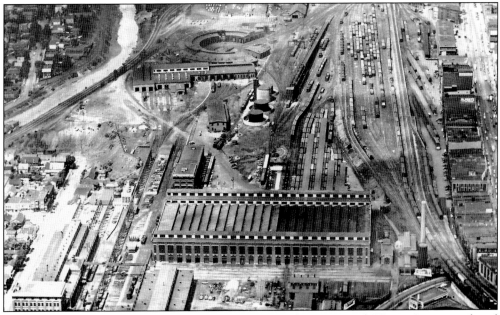

This 1951 aerial photograph shows the Delaware, Lackawanna and Western's city yard and engine-servicing facility in Scranton. In the center of the photograph is the railroad's erecting shop. The roundhouse, enlarged in 1937, lies in the upper portion of this image. At this time, the Lackawanna was still using a number of steam locomotives in addition to its rapidly expanding diesel fleet. (Steamtown National Historic Site collection.)

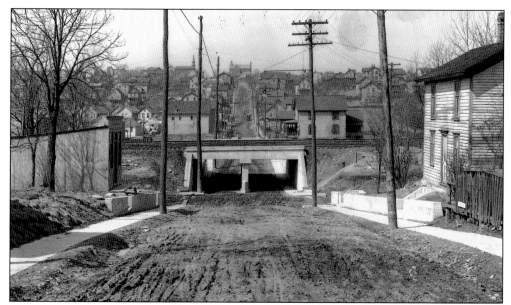

During the early years of the 20th century, the Delaware, Lackawanna and Western Railroad eliminated as many grade crossings as possible. Besides posing a danger to traffic, these crossings proved to be a considerable expense in the years preceding automation, as each required a watchman to manually raise and lower the protective gates. In this 1913 photograph, Scranton's Ash Street crossing has been eliminated via construction of a concrete underpass. (Steamtown National Historic Site collection.)

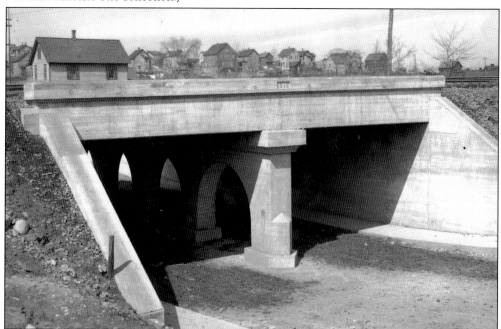

The Delaware, Lackawanna and Western embraced concrete as a building material during its period of modernization. The simple viaduct carrying the railroad over Ash Street evidences this building preference. This bridge remains in service today. (Steamtown National Historic Site collection.)

Wherever possible, railroads attempted to be as self-sufficient as possible. With the abundant supply of coal as a fuel source, the Delaware, Lackawanna and Western would come to generate as much of its own electricity as possible. This 1910 image depicts the company's powerhouse at the Nay Aug yard. (Syracuse University Library collection.)

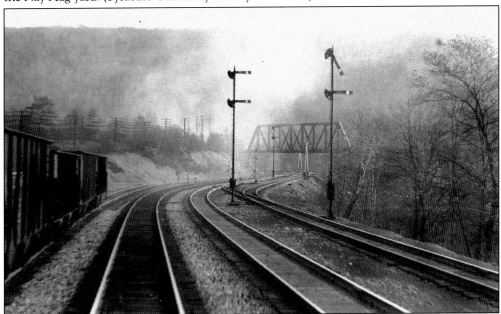

The Delaware, Lackawanna and Western's Nay Aug yard is seen from the back of a speeding train in this c. 1915 image. The Winton branch of the railroad originated in this yard while the Erie Railroad's Wyoming division crossed overhead on the bridge in the center of the image. Today Interstate 84 crosses this location on a towering overhead bridge. (Railroad Museum of Pennsylvania, Pennsylvania Historical and Museum Commission, reprinted with permission.)

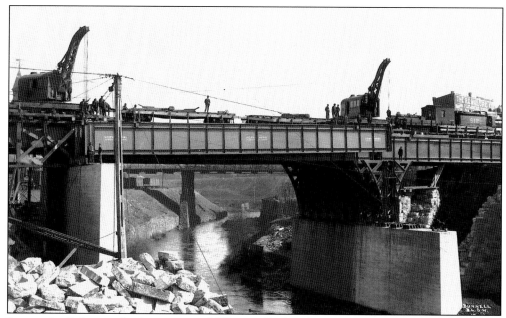

Just as the Delaware, Lackawanna and Western Railroad outgrew its original wooden trestle over the Lackawanna River in the 1870s, by the dawn of the 20th century, the stone arch bridge that had replaced it was also deemed inadequate. To that end, the railroad designed a newer, larger span across the river. In October 1907, two steam cranes lower a steal girder into place as construction continues. (Steamtown National Historic Site collection.)

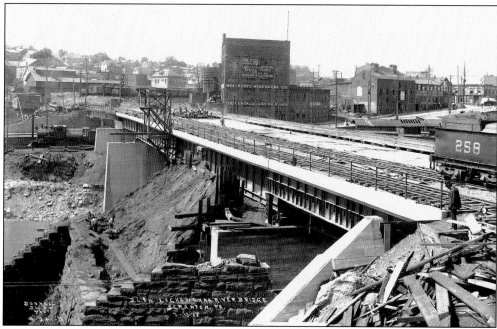

In this July 1908 view, trains are operating across the new bridge and the steel frame of Bridge 60 Tower has been erected. In the foreground is the stone facade of the Delaware and Hudson Railroad's tunnel under the bridge, which had yet to be removed. (Steamtown National Historic Site collection.)

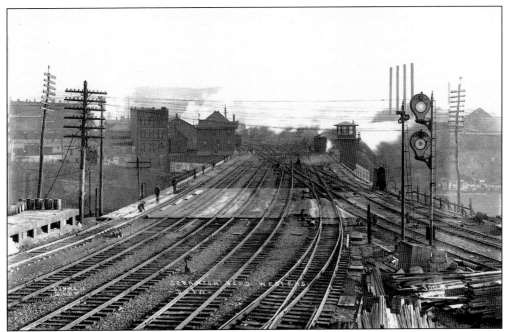

Upon completion of the third and final bridge over the Lackawanna River, this location was designated Bridge 60 Interlocking with its own interlocking. The name is derived from the structure's location, as this was the 60th bridge on the Scranton division of the Delaware, Lackawanna and Western Railroad. (Steamtown National Historic Site collection.)

The demolition of the stone arch bridge over the Lackawanna River enabled the Delaware and Hudson to remove its single-track tunnel under the bridge and expand its right-of-way to include three tracks as seen in this 1911 view looking south from Lackawanna Avenue. The Central Railroad of New Jersey is visible on the right. (Steamtown National Historic Site collection.)

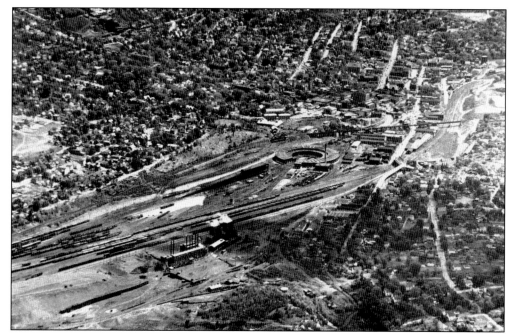

To service its locomotives operating in the Lackawanna Valley, the Delaware and Hudson Railroad constructed a large roundhouse and servicing facility at its Carbondale yard, approximately 15 miles north of Scranton. Visible behind the roundhouse is the Scranton division of the New York, Ontario and Western Railway, which crossed much of downtown Carbondale on an overhead right-of-way. (Steamtown National Historic Site collection.)

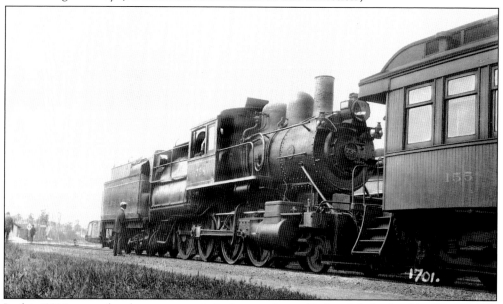

In this 1921 image, a local passenger train is about to depart Carbondale for the 15-mile trip south to Scranton. The antiquated wooden coaches of the late 19th century, bumped from premier assignments by newer cars, would find a home on the Scranton-to-Carbondale commuter service and continued to operate into the 1950s. (Railroad Museum of Pennsylvania, Pennsylvania Historical and Museum Commission, reprinted with permission.)

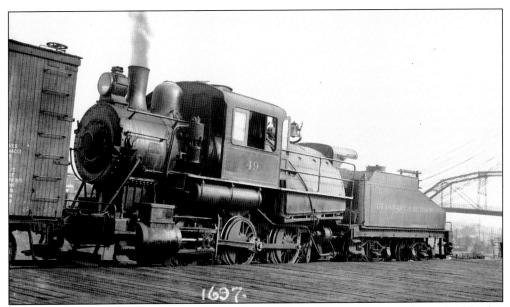

Delaware and Hudson 0-6-0 switcher No. 49 pauses at the Scranton passenger terminal in this image from 1921. The presence of a boxcar is unusual, as this area was used almost exclusively for passengers while freight traffic was handled at a separate facility on Wyoming Avenue. (Railroad Museum of Pennsylvania, Pennsylvania Historical and Museum Commission, reprinted with permission.)

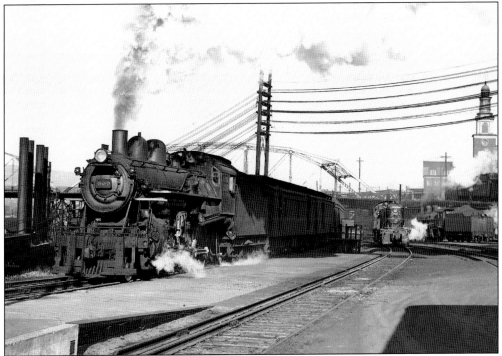

Built in 1903, Delaware and Hudson Railroad engine No. 500 was already an antique by the time this 1946 photograph was taken. The power plant in the background was constructed to supply direct current for many of downtown Scranton's elevators. (Edward S. Miller photograph.)

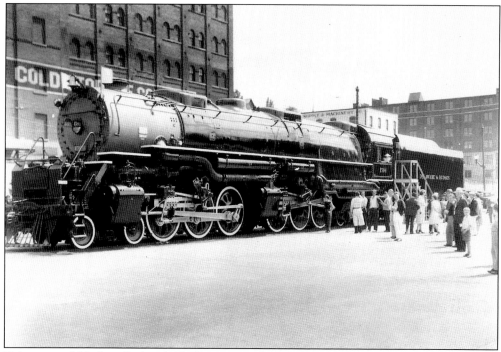

Delaware and Hudson Railroad Challenger-type locomotives were the pinnacle of locomotive design in the 1940s. These machines soon became the unofficial flagship of the company and thus were occasionally placed on public exhibition. While usually assigned to the steep grades north of Carbondale, locomotive No. 1508 is seen on display at the company's freight house along Wyoming Avenue in 1949. (Earl Trygar collection.)

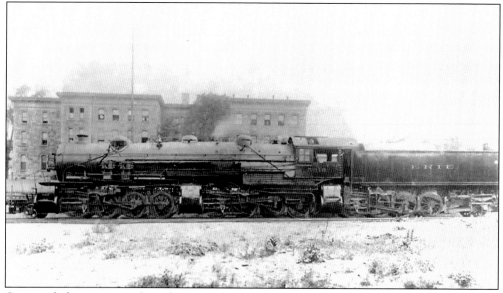

Commonly known as triplexes because of their three sets of drive wheels, the three P-1-class locomotives owned by the Erie Railroad were perhaps the largest locomotives of their time. Mostly used in pusher service in New York State, locomotive No. 5016 makes a rare appearance in Dunmore for special exhibition around 1920. (Earl Trygar collection.)

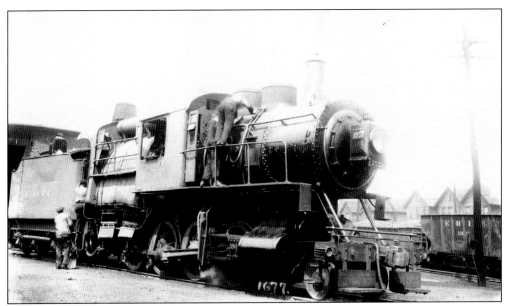

While the Erie Railroad maintained a low-key presence in downtown Scranton, the company maintained a massive shop complex just outside the city limits in the borough of Dunmore. Here Erie Railroad No. 1558 is serviced in the Dunmore yard in September 1921. By the time this photograph was taken, the Erie Railroad had long since gained control the former Erie and Wyoming Valley. (Railroad Museum of Pennsylvania, Pennsylvania Historical and Museum Commission, reprinted with permission.)

At its massive car shops in Dunmore, the Erie Railroad constructed hundreds of freight cars and cabooses. This restored example of a Dunmore caboose is seen on the Black River and Western Railroad in New Jersey in 1993. (Author's collection.)

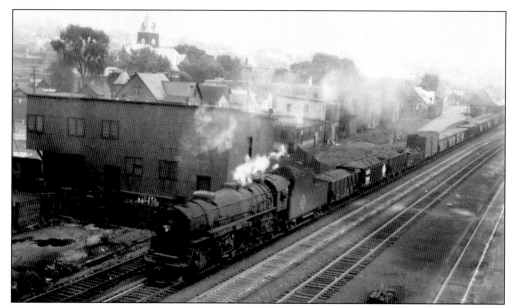

Heading north on a route shared with the Delaware and Hudson Railroad, an Erie Railroad train charges north through Carbondale. The two companies shared this route, known as the Jefferson division, between the coalfields of northeastern Pennsylvania north into New York State. In the upper right of this *c.* 1930s photograph is the Delaware and Hudson's Carbondale station. (Railroad Museum of Pennsylvania, Pennsylvania Historical and Museum Commission, reprinted with permission.)

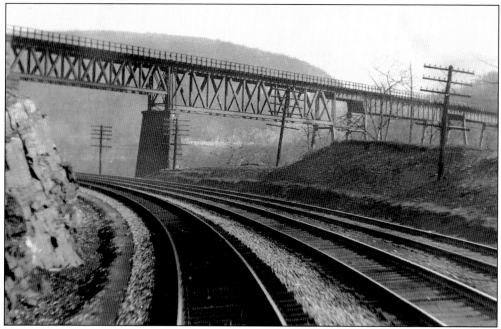

To reach the rich coal deposits north of Scranton, the Erie Railroad constructed the so-called Jessup branch off its main line in Dunmore. This required an impressive span to carry trains over Roaring Brook as well as the Delaware, Lackawanna and Western Railroad. (Railroad Museum of Pennsylvania, Pennsylvania Historical and Museum Commission, reprinted with permission.)

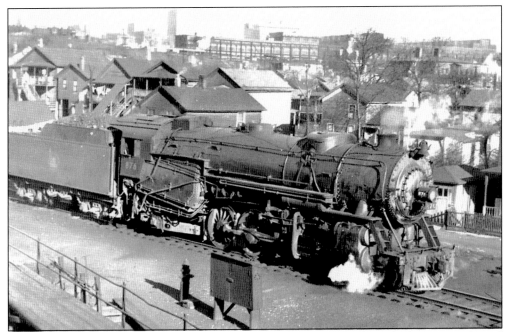

A Central Railroad of New Jersey heavy freight locomotive moves through the company's yard in south Scranton in this late-1940s photograph. Note the proximity of the neighboring houses to the yard tracks. The shops of the Delaware, Lackawanna and Western are visible to the rear of this photograph. (Lackawanna Historical Society collection.)

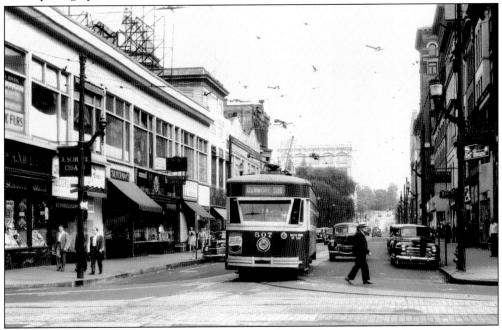

In 1946, a Scranton Transit Company streetcar travels along Spruce Street at Wyoming Avenue. The shiny new automobiles surrounding the Osgood-Bradley-built car led to the abandonment of the entire streetcar system within the next decade. (Lackawanna Historical Society collection, Edward S. Miller photograph.)

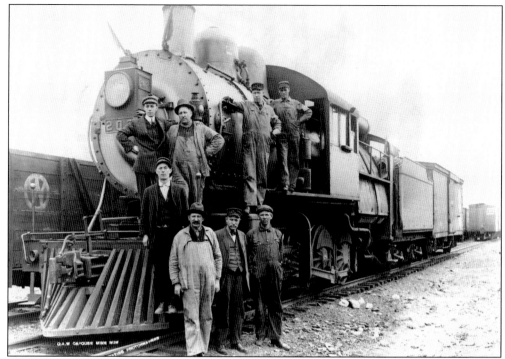

The New York, Ontario and Western Railway built its Capouse branch to enable the railroad to serve several collieries south of Scranton. Eventually the branch extended to a connection with the Lehigh Valley Railroad near Pittston. As seen in this *c.* 1900 photograph, several employees pose with a train identified as the "Capouse Mine Run." (Railroad Museum of Pennsylvania, Pennsylvania Historical and Museum Commission, reprinted with permission.)

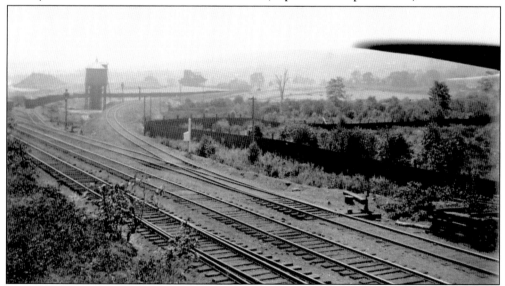

The Capouse branch left the New York, Ontario and Western main line at the aptly named Capouse Junction, seen here. The Delaware, Lackawanna and Western Railroad also operated over this branch between Capouse Junction and Cayuga Junction at Keyser Valley via trackage rights. (Ontario and Western Railway Historical Society collection.)

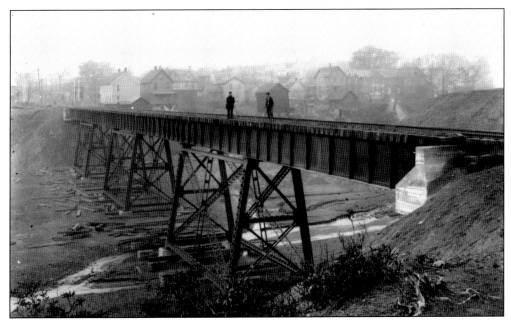

Construction of the Capouse branch necessitated a substantial trestle over Leggets Creek in North Scranton. This southwest view shows the recently completed span that replaced an earlier wooden structure. Note the construction debris in the creek bed below and the Oak Street grade crossing on the opposite side of the bridge. (Ontario and Western Railway Historical Society collection.)

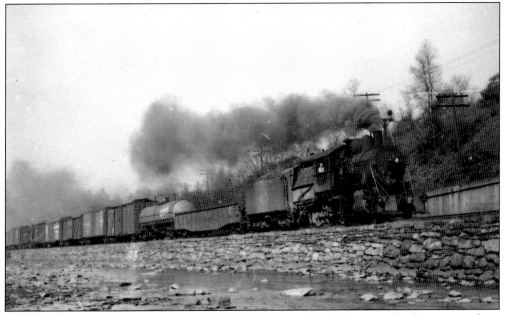

Running south toward Scranton, a New York, Ontario and Western freight steams along the Lackawanna River through Archbald in 1940. As evidenced by the wide variety of cars on the train, this is a local freight stopping at various locations as it works its way south. (Railroad Museum of Pennsylvania, Pennsylvania Historical and Museum Commission, reprinted with permission.)

About 10 miles north of Scranton, the New York, Ontario and Western Railway constructed a sizable locomotive-servicing facility in the town of Mayfield, a few miles south of Carbondale. Here a 2-8-0 camelback locomotive pauses at the coal pockets at the Mayfield yard in 1947. (Railroad Museum of Pennsylvania, Pennsylvania Historical and Museum Commission, reprinted with permission.)

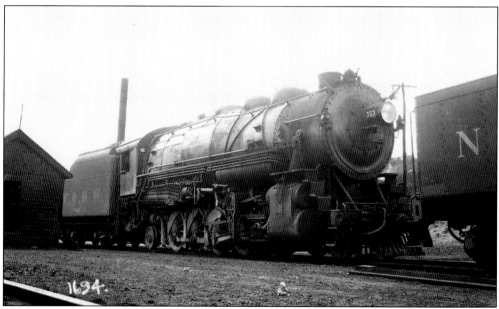

By far the largest steam locomotives used on the New York, Ontario and Western were the 2-10-2 locomotives delivered by ALCO in 1915. Like others in its class, engine No. 353 seen at the Mayfield yard in 1921 was given the unofficial nickname "the Bull Moose." (Railroad Museum of Pennsylvania, Pennsylvania Historical and Museum Commission, reprinted with permission.)

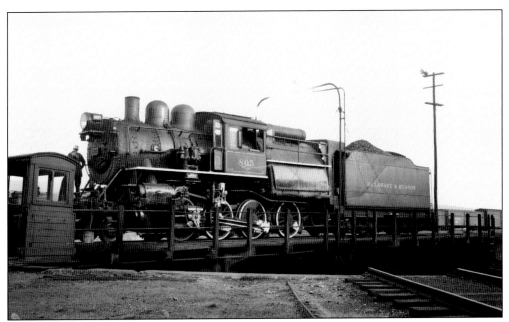

Short of motive power in 1947, the New York, Ontario and Western turned to the neighboring Delaware and Hudson Railroad and purchased locomotive No. 805, seen here on the Mayfield turntable on August 10, 1947. A 1903 product of Scranton's Dickson works, this engine was renumbered 701 for less than a year for its new owner before being retired. (Railroad Museum of Pennsylvania, Pennsylvania Historical and Museum Commission, reprinted with permission.)

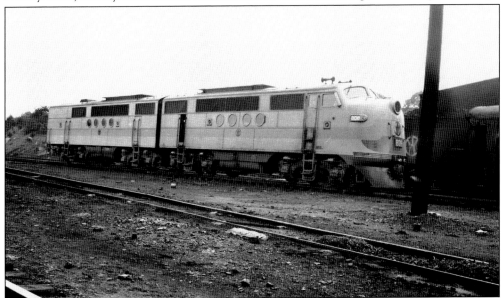

The New York, Ontario and Western was the first of the railroads servicing Scranton to completely abandon steam locomotives in favor of diesel. In this 1947 image, FT locomotive set No. 803 sits in the Mayfield yard. Delivered two years previous, the FT locomotives were part of an order for eight sets the company took possession of that year. The arrival of these units coupled with the overall decline of traffic led to the demise of steam on the line. (Railroad Museum of Pennsylvania, Pennsylvania Historical and Museum Commission, reprinted with permission.)

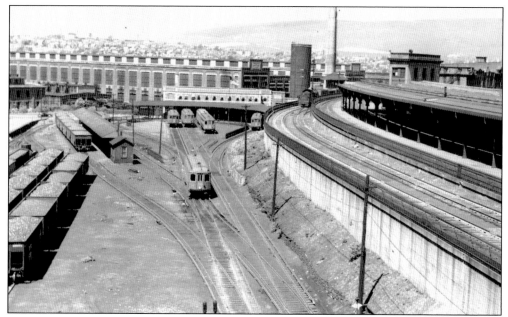

The Lackawanna and Wyoming Valley Railroad was far more than a transit system. This interurban, as such systems were called, carried general freight as well as coal shipments along its route. This 1940 image shows the company's Scranton yard and the Delaware, Lackawanna and Western Railroad to the right. (Lackawanna Historical Society collection, Edward S. Miller photograph.)

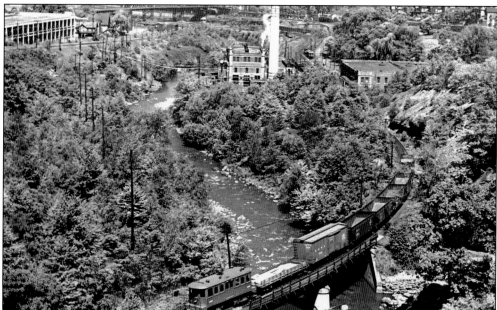

In 1939, a typical Laurel Line freight train heads south past the company's powerhouse and car shops. In this view looking west toward Scranton, the train is about to enter the Crown Avenue tunnel under south Scranton. The original "Over the Hill" alignment, kept in service even after the tunnel's 1905 opening, is visible in the upper left of this photograph. (Lackawanna Historical Society collection, Edward S. Miller photograph.)

Five

Winds of Change during the Postwar Years

After surviving the Great Depression, railroads were asked to supply the nation's war machine as never before. Stored locomotives and cars were placed back in service after being idled during the 1930s. During World War II, America's railroads found renewed purpose while hauling over 90 percent of the nation's freight and nearly all its servicemen and women.

As the war drew to a close, the nation's railroads turned their attention to the diesel locomotive. While this type of motive power began to appear in the 1930s, wartime restrictions prevented the railroads from fully embracing the new technology. With those constraints removed at war's end, railroads began to replace their aging steam locomotives as quickly as they could afford to do so. While a new diesel could easily cost twice as much as a steam locomotive, the cost would be recovered long before the unit was deemed obsolete. Diesel locomotives needed significantly fewer people to support their operation, mainly due to the fact they required much less downtime and were far more reliable than their predecessors. Diesel locomotives could be strung together in multiples and operated by just a single crew, whereas each steam locomotive required its own engineer and fireman, even when used in groups.

In 1949, the New York, Ontario and Western Railway was the first of Scranton's railroads to retire its steam locomotive fleet. Other railroads were not far behind, and by 1953, the railroads of Scranton had completed their transition to diesel. At the same time, railroads were revamping their passenger service with sleek new streamlined trains in an effort to hold the public's interest in the face of competition from the airplane and the automobile. The most notable of these to call on Scranton was the Delaware, Lackawanna and Western Railroad's *Phoebe Snow*, a streamliner that ran from Hoboken, New Jersey, to Buffalo, New York, with connecting service to Chicago over the New York, Chicago and St. Louis Railroad (Nickel Plate Road).

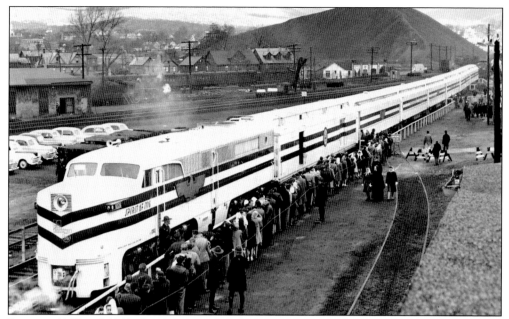

Between 1947 and 1949, the American Freedom Train toured all 48 states with a showcase of national treasures including the Declaration of Independence and the United States Constitution. This image shows the American Freedom Train on exhibit in the Delaware and Hudson Railroad's Green Ridge yard on November 12, 1947. (Lackawanna Historical Society collection.)

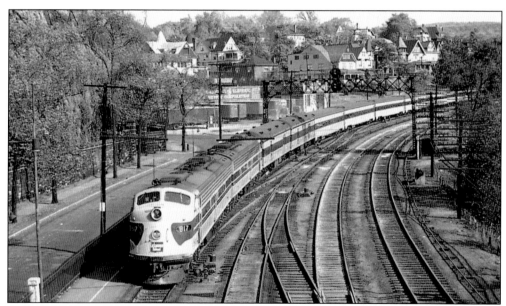

In 1949, the Delaware, Lackawanna and Western Railroad launched its new flagship train called the *Phoebe Snow* as a nod to the fictional character created by the company decades before. The *Phoebe Snow* offered lavish accommodations aboard its streamlined cars and traveled the length of the railroad from Hoboken, New Jersey, to Buffalo, New York. Here the westbound *Phoebe Snow* pulls into Scranton as viewed from Scranton's Spruce Street bridge. (Edward S. Miller photograph.)

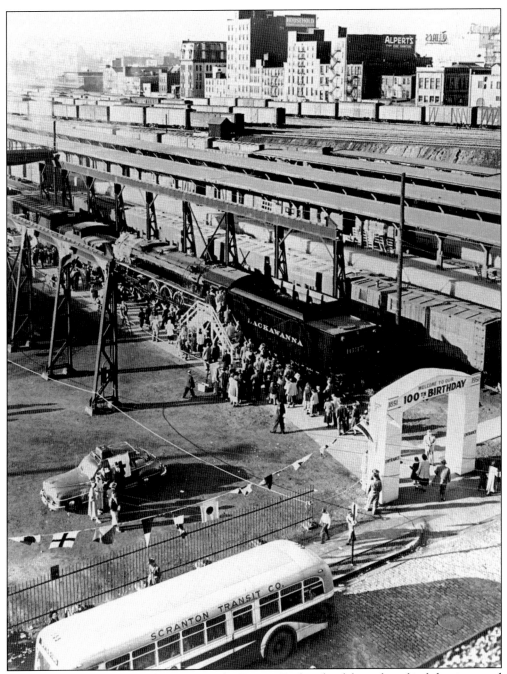

In 1951, the Delaware, Lackawanna and Western Railroad celebrated its birthday in grand tradition. The company was still a healthy, vibrant enterprise eager to show off its achievements over the previous 100 years. In this view, throngs of spectators inspect the displays at Scranton's city yard along Washington Avenue. (Steamtown National Historic Site collection.)

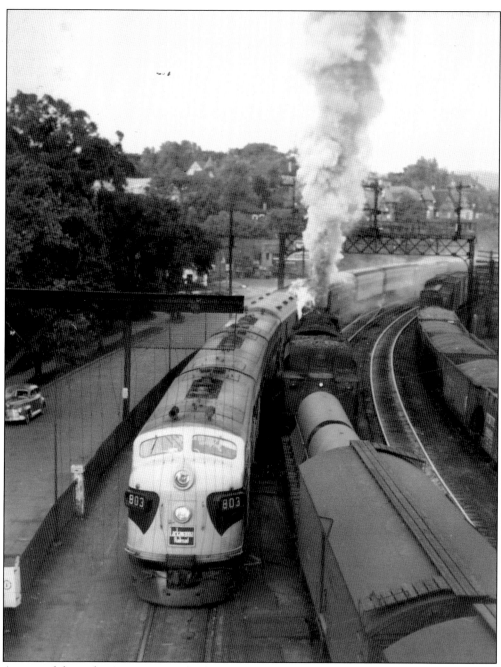

As viewed from the Spruce Street bridge, the Delaware, Lackawanna and Western Railroad's *Pocono Express* arrives in Scranton behind a set of F-3 diesels in 1949. Steam is still very much alive on the Delaware, Lackawanna and Western at this time as a train with several milk cars on the head end leaves town in a fury of steam and smoke. (Railroad Museum of Pennsylvania, Pennsylvania Historical and Museum Commission, reprinted with permission.)

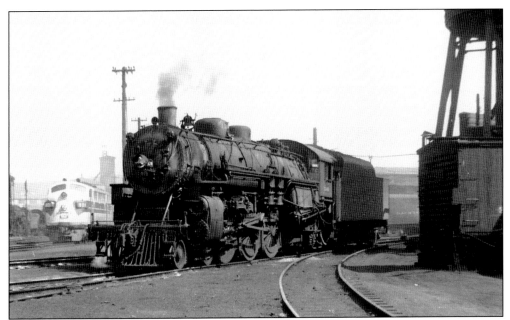

Delaware, Lackawanna and Western engine No. 1140 rolls through the city yard in this telling 1947 photograph. Built for high-speed passenger service, this 1923 locomotive is already on borrowed time as many of its class have either been scrapped or converted into 0-8-0 switchers. Note the four-month-old set of diesels lurking in the background. (Railroad Avenue Enterprises photograph.)

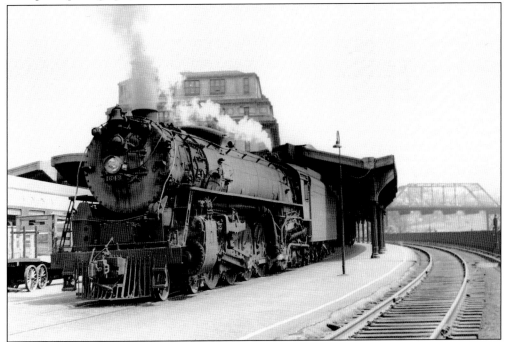

Even in 1950, steam-powered passenger trains could still be found on the Delaware, Lackawanna and Western. Engine No. 1649, built in 1934, was nearing the end of its service life when this picture was taken at Scranton's passenger station. (Railroad Avenue Enterprises photograph.)

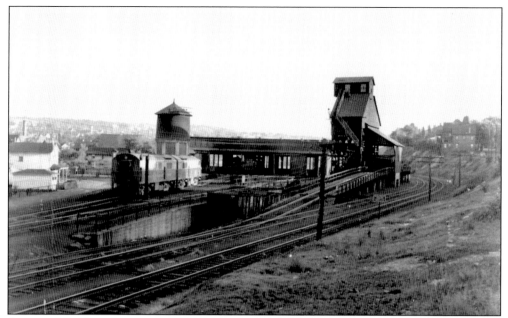

A pair of Baldwin Locomotive Works–built diesel-electric locomotives rest at the Central Railroad of New Jersey's Scranton roundhouse in this *c.* 1950 photograph. In the foreground is the company's main line to Wilkes-Barre and points south. This facility existed until 1955 when much of the surrounding neighborhood was devastated by Hurricane Diane. (Lackawanna Historical Society collection.)

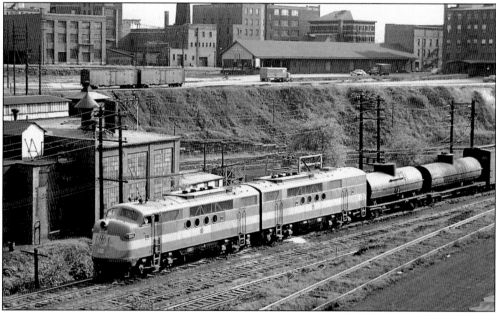

A set of New York, Ontario and Western Railway FT diesels prepares to leave the interchange yard maintained with the Central Railroad of New Jersey in this October 1953 photograph. Behind the diesels, across the Lackawanna River, two refrigerated cars are spotted behind the former Delaware and Hudson Railroad's passenger station. Visible above those two cars is the diamond branch of the Delaware, Lackawanna and Western Railroad. (Edward S. Miller photograph.)

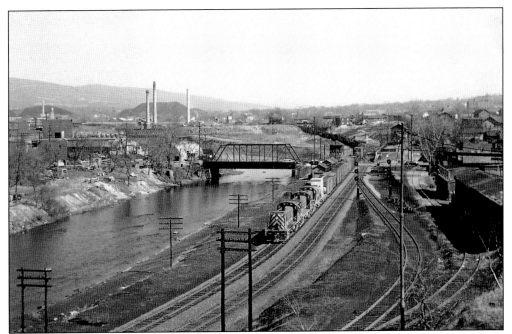

In March 1953, a trio of Delaware and Hudson RS3 diesels leads a southbound freight though Scranton. The train has just passed the Carbon Street tower as it travels along the Lackawanna River. In the foreground is the Strawberry Hill branch, which enabled passenger trains to reach the downtown Scranton station. (Edward S. Miller photograph.)

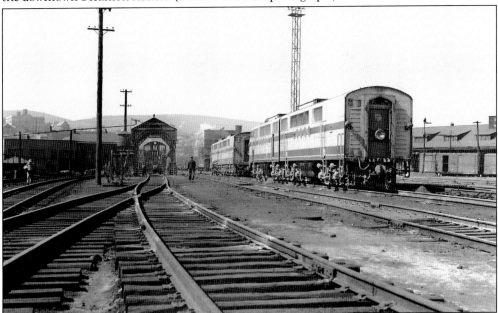

At the close of World War II, the Delaware, Lackawanna and Western began taking delivery of several FT-type diesel-electric units from General Motors. These engines were grouped in sets of two and three units, which together were considered to be one locomotive. As seen here in 1950, several sets of FT locomotives await their next call to service in Scranton. (Railroad Avenue Enterprises photograph.)

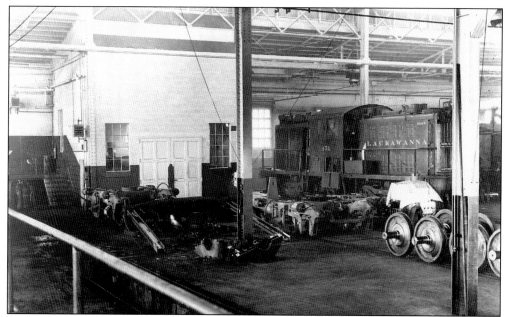

The clean, organized interior of the Delaware, Lackawanna and Western Railroad's Scranton diesel shop stands in stark contrast to the dismal conditions in the steam locomotive shops depicted earlier in this book. Portions of the diesel shop actually date back to the Civil War, as the building was modified for each new generation of motive power and never actually torn down. (Railroad Avenue Enterprises photograph.)

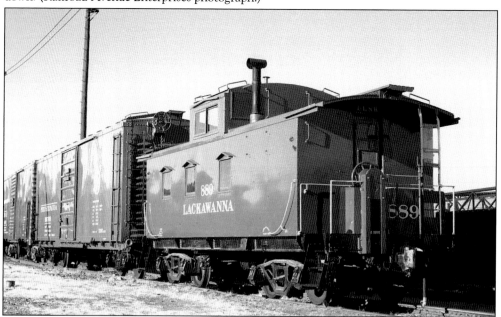

As the Delaware, Lackawanna and Western scrapped its steam locomotive fleet in the decade following World War II, the company found a unique way of reusing the tenders from those condemned engines. Dozens of new cabooses were constructed at the Keyser Valley shops using the old tender frames and new car bodies. This preserved example from 1952 is on display at Steamtown National Historic Site. (Author's collection.)

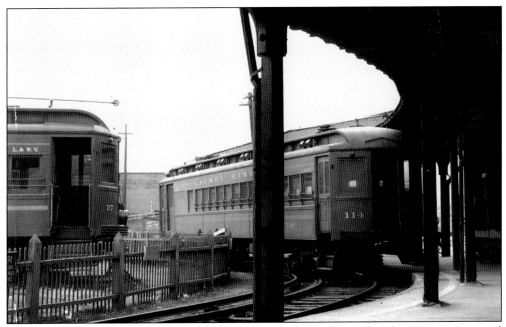

The vacant platforms at the Lackawanna and Wyoming Valley Railroad's Scranton terminal give mute testimony to the impending demise of passenger service on the line. It is October 1952, and the Laurel Line will cease passenger service at the end of the year. (Lackawanna Historical Society collection.)

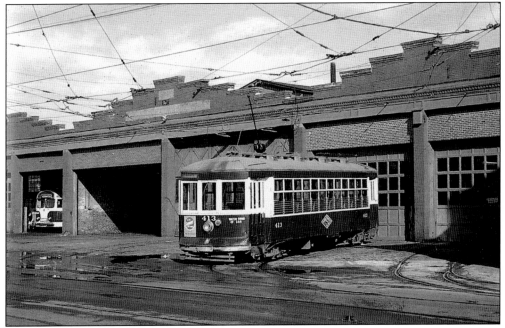

The days of electric streetcars were coming to a close at the time of this February 1953 photograph. The demise of trolley service is well illustrated by this scene at the Scranton Transit streetcar shops on Providence Road, as most of the facility has been converted into a bus garage. (Edward S. Miller photograph.)

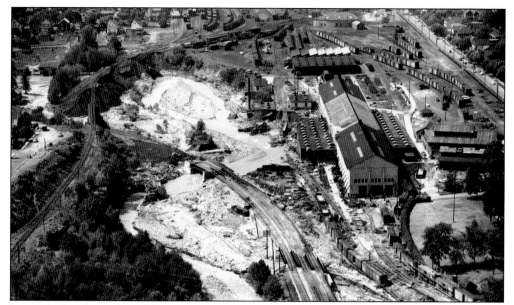

In 1955, already weakened by a downturn in traffic, the Delaware, Lackawanna and Western Railroad was dealt a crippling blow by Mother Nature. In August of that year, Hurricane Diane brought heavy rainfall, and resulting floodwaters washed out much of the line east of Scranton. As seen in the days after, flooding has devastated the railroad's main line through Dunmore and also eroded a portion of the Erie Railroad running overhead. (Railroad Museum of Pennsylvania, Pennsylvania Historical and Museum Commission, reprinted with permission.)

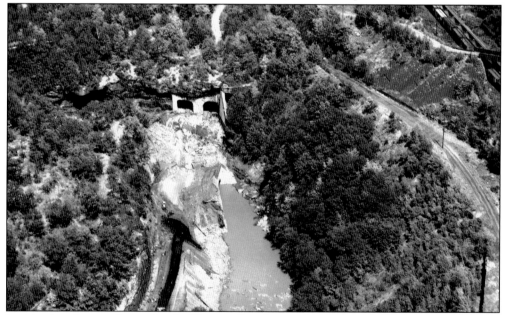

In this view, damage from a flooded Roaring Brook is readily apparent at the west portal of the Nay Aug tunnel. At one time during the flood, water flowed freely through the tunnel from east to west. The 1955 flood is often cited as one of the principal reasons the Delaware, Lackawanna and Western elected to merge with its longtime rival, the Erie Railroad. (Railroad Museum of Pennsylvania, Pennsylvania Historical and Museum Commission, reprinted with permission.)

Six

DECLINE, MERGERS, AND MOTHER NATURE

No industry was as more responsible for both the success and demise of Scranton's railroads as anthracite coal. With the fortunes of coal and rail so intertwined, the collapse of one would certainly devastate the other. Such a cataclysm indeed took place in the years following World War II. By the dawn of the 1950s, Americans began using oil, natural gas, and electricity to heat and power their everyday lives, and the demand for coal dropped to a catastrophic low, as did most every railroad's bottom line.

The changeover from steam to diesel drastically changed the railroad landscape. With the ease of maintenance and operation offered by this new breed of iron horse, the facilities that maintained steam and often the employees themselves were deemed obsolete. Thousands found themselves without jobs as many roundhouses and locomotive shops were modified, torn down, or abandoned where they stood.

At the same time, Pres. Dwight D. Eisenhower's Interstate Highway System captured the attention of a nation, as Americans took to the road in record numbers. Travel by rail was no longer seen as modern and elegant but as a relic from earlier times and a necessary evil for those who still needed to ride. One by one, Scranton's railroads discontinued passenger service. The last railroad to offer passenger trains out of Scranton, the Erie-Lackawanna Railroad, discontinued that service in 1970.

Some lines, such as the New York, Ontario and Western Railway, shut down all together. The Central Railroad of New Jersey abandoned its line into Scranton. Other railroads merged to improve their stability, as was the case with the Erie Railroad and the Delaware, Lackawanna and Western Railroad in 1960. The resulting company, the Erie-Lackawanna Railroad, survived until becoming part of Conrail along with several other companies in 1976.

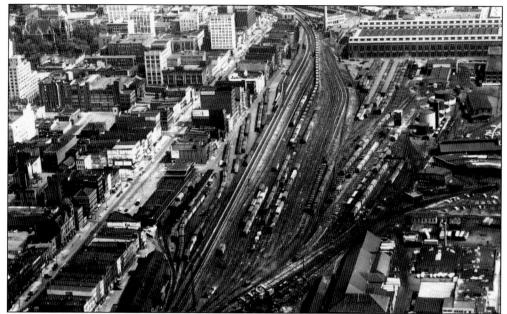

By the time this aerial photograph was taken in 1955, many changes had occurred in the Delaware, Lackawanna and Western Railroad's city yard as a result of the complete conversion to diesel locomotives. Most of the roundhouse has been torn down, and the coal trestle has been removed. (Railroad Museum of Pennsylvania, Pennsylvania Historical and Museum Commission, reprinted with permission.)

In May 1959, a set of F3 diesels passes through the wash rack in Scranton. Presenting a clean image to the public was as important in the diesel era as it was in days of the steam locomotive. Even in the face of declining revenue and an impending merger with the Erie Railroad, the Delaware, Lackawanna and Western still took pride in its image. (Railroad Avenue Enterprises photograph.)

Classified as H24-66 locomotives by builder Fairbanks-Morse, these monstrous units were more widely known as "Train Masters." Delivered in 1953, engine No. 857 and an unidentified sister unit idle at Scranton's Bridge 60 on August 21, 1958. Train Masters saw both freight and passenger service on the Delaware, Lackawanna and Western and were frequent visitors to Scranton. (Railroad Avenue Enterprises photograph.)

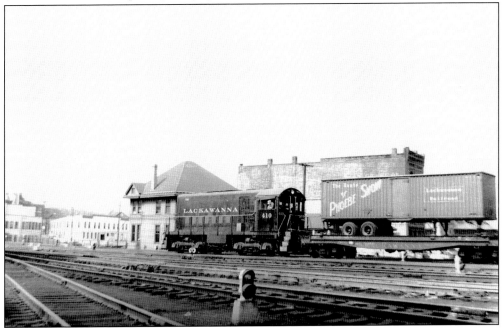

Later on the same day as the photograph above, an ALCO HH660 locomotive built in 1940 handles a trailer-on-flatcar movement. More commonly known as piggyback cars, these flatcars would carry truck trailers over a long distance to their destinations, where they would be unloaded to make local deliveries. (Railroad Avenue Enterprises photograph.)

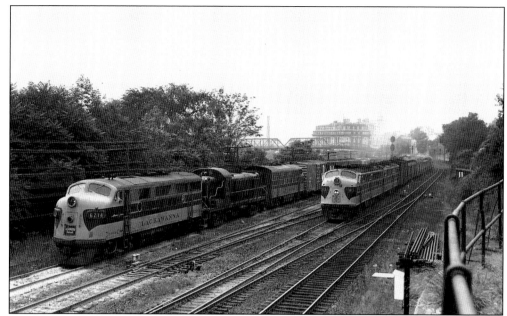

In 1961, a year after the merger of the Erie and Delaware, Lackawanna and Western Railroads, a freight train waits as the *Erie-Lackawanna Limited* departs Scranton. Engine No. 6214 and its companions are former Delaware, Lackawanna and Western units while the passenger train is led by a former Erie Railroad locomotive. The *Erie-Lackawanna Limited* briefly replaced the *Phoebe Snow* between 1960 and 1963. (David Monte Verde collection, William Nixon photograph.)

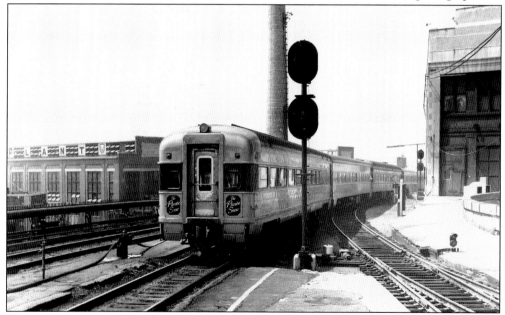

The *Phoebe Snow* returned to the rails in 1963 after a three-year hiatus, but by the time of this August 1966 photograph, its days were numbered once more. Expenses mounted as the company lost contracts to haul mail and passengers deserted trains in favor of the automobile and air travel. The *Phoebe Snow* made its last run on November 28, 1966. (Railroad Avenue Enterprises, Bob Pennesi photograph.)

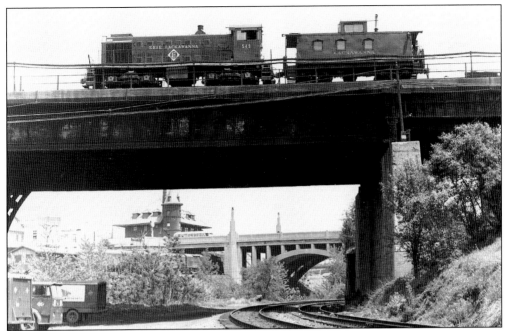

The year is 1964, and an Erie-Lackawanna Railroad switcher crosses Bridge 60 in Scranton. Note that even four years after the merger, caboose No. 887 still carries its original lettering. Below the bridge is the main line of the Delaware and Hudson Railroad while the Central Railroad of New Jersey is seen in the background. (Railroad Avenue Enterprises, Bob Pennesi photograph.)

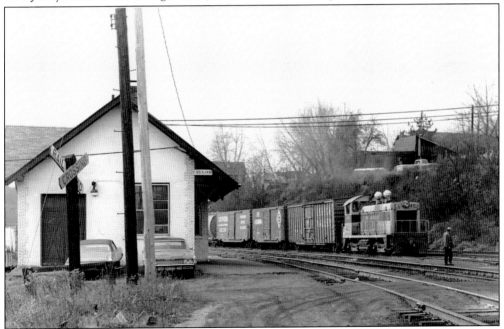

In 1974, an Erie-Lackawanna local freight arrives in the Taylor yard having traversed the former Delaware, Lackawanna and Western Railroad Bloomsburg branch. The building to the left is the former Taylor station for the Lackawanna, now used as a crew office for trains operating in and out of the yard. (Railroad Avenue Enterprises, Bob Pennesi photograph.)

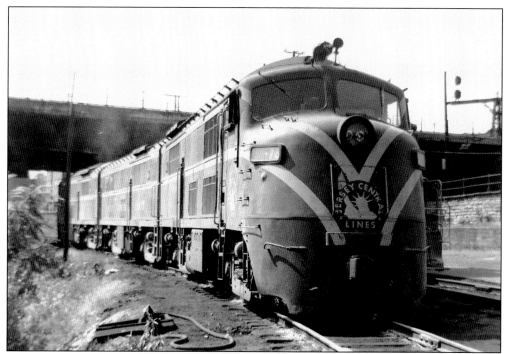

Classified as DR 4-4-1500 locomotives by the Baldwin Locomotive Works, units such as Central Railroad of New Jersey engine No. 78 were more commonly referred to as "Baby Face Baldwins" for their unique styling. In September 1961, a set of these units rest at the company's freight station in Scranton. (Railroad Avenue Enterprises, Bob Pennesi photograph.)

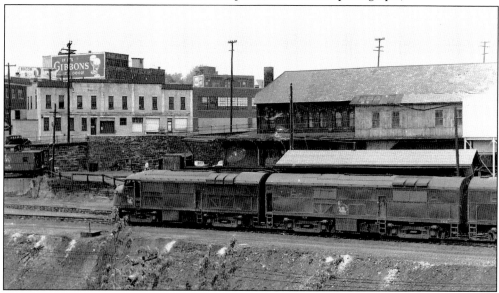

Another set of Baldwin-built diesels departs the Central Railroad of New Jersey freight terminal in May 1964. This location was a favorite of railfans at the time, as a constant parade of motive power could be photographed on the Delaware, Lackawanna and Western Railroad, the Delaware and Hudson Railroad, and the Central Railroad of New Jersey. (Railroad Avenue Enterprises, Bob Pennesi photograph.)

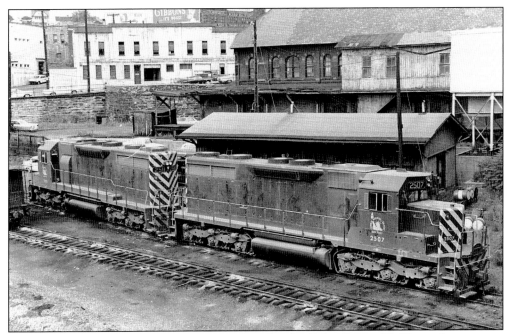

In August 1965, a brand-new set of Central Railroad of New Jersey SD-35-type locomotives idles in Scranton. Behind these locomotives is the 1910 former passenger station, long used as a storage area following the discontinuance of passenger service on this route. (Railroad Avenue Enterprises, Bob Pennesi photograph.)

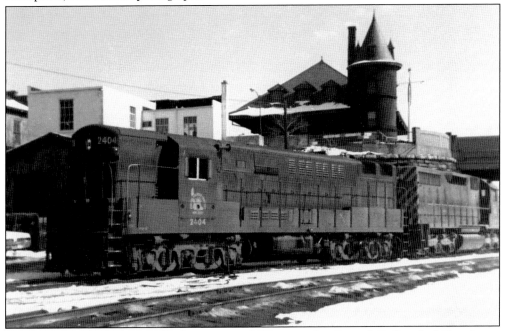

In contrast to the Delaware, Lackawanna and Western, the Central Railroad of New Jersey rarely operated its Train Master diesels into the city of Scranton, instead assigning them to commuter trains in New Jersey. In this February 1967 view, one of these Train Masters makes a rare appearance in Scranton. (Lawrence Malski photograph.)

Delaware and Hudson Railroad locomotive No. 606 was barely a month old when it was photographed on May 23, 1964, heading south under the Delaware, Lackawanna and Western Railroad in Scranton. As coal traffic dwindled after World War II, the Delaware and Hudson survived by concentrating on "bridge traffic," which is moving cars from one railroad to another over its tracks. (Railroad Avenue Enterprises, Bob Pennesi photograph.)

On October 19, 1974, a Carbondale-bound local freight heads north through Scranton. The track closest to the photographer is the so-called Strawberry Hill spur, which originally led to the company's downtown Scranton passenger station. (Railroad Avenue Enterprises, Bob Pennesi photograph.)

In 1972, Hurricane Agnes damaged significant portions of the Lehigh Valley Railroad in areas south of Scranton. This necessitated lengthy detours for Lehigh Valley trains over the Delaware and Hudson Railroad through New York and Pennsylvania. One such detour train is seen southbound along the Lackawanna River in Scranton. (Lawrence Malski photograph.)

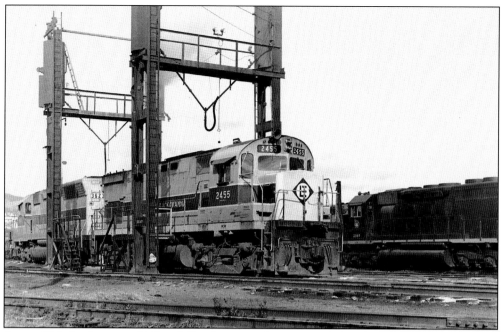

A set of Erie-Lackawanna Railroad diesels rests at the company's diesel sand facility in Scranton during November 1973. By this time, the Central Railroad of New Jersey had rerouted its trains over the Erie-Lackawanna out of Scranton as evidenced by the foreign carrier's motive power in the yard. (Railroad Avenue Enterprises, Bob Pennesi photograph.)

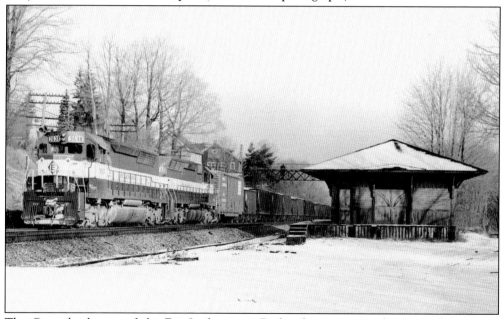

The Conrail takeover of the Erie-Lackawanna Railroad was a mere three months away as the company's two bicentennial units lead an eastbound freight through Moscow in January 1976. Today Moscow is the destination for many Steamtown National Historic Site excursions, and both the passenger and freight stations have been restored to their original appearances. (Railroad Avenue Enterprises, Bob Pennesi photograph.)

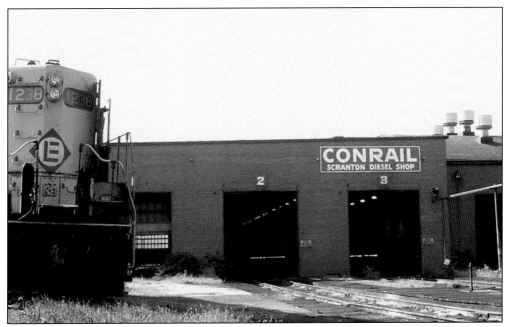

It is the summer of 1976, and although the Erie-Lackawanna colors remain on the unit in the foreground, this is now Conrail's yard in downtown Scranton. Over the next several years, Conrail curtailed operations on the former Erie-Lackawanna lines around Scranton. (Ed Kaspriske photograph.)

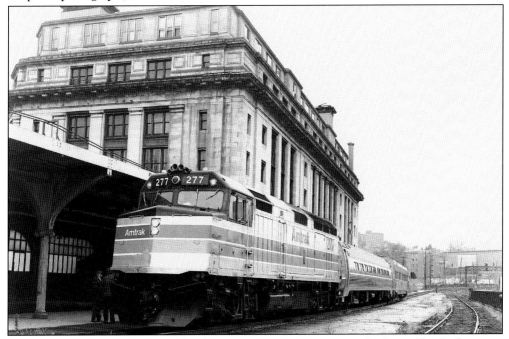

In the late 1970s, Amtrak contemplated returning passenger service to the former Erie-Lackawanna through Scranton. Here an Amtrak inspection train pauses at the largely vacant Delaware, Lackawanna and Western station in Scranton. Later that decade, drastic cuts in Amtrak funding destroyed the possibility of returning service into the city. (Tom Nemeth photograph.)

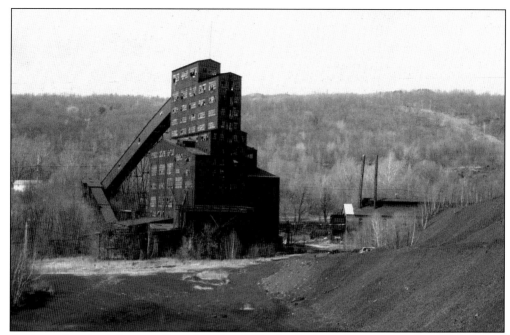

As the anthracite industry collapsed in the 1950s, the facilities that were used to maintain the flow of anthracite coal to market were rendered obsolete. Many were torn down, while others were abandoned in place such as this breaker in Swoyersville. (Ken Ganz photograph.)

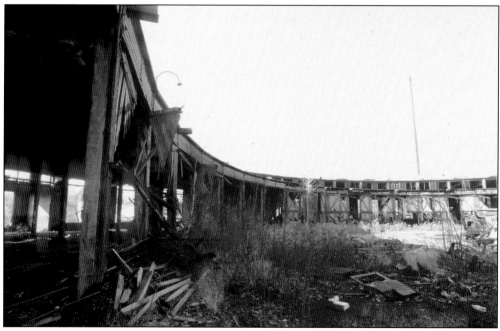

As steam operations on the Delaware and Hudson Railroad came to a close, the company ceased use of the massive roundhouse in Carbondale. As shown prior to its demolition in the early 1990s, the abandoned building stands in stark contrast to the activity that once took place here. (Ken Ganz photograph.)

Seven

Rising from the Ruins

As the 1980s dawned, the railroad scene in northeastern Pennsylvania was indeed quite grim. Conrail eventually ceased operations over most of the Erie-Lackawanna Railroad in the area. By 1985, the Delaware and Hudson Railroad had abandoned nearly all its trackage north of Scranton in favor of the cast-off Delaware, Lackawanna and Western Railroad route it had acquired in 1976. The need to preserve local freight service led to the creation of the Lackawanna County Railroad Authority, and the organization acquired a 16-mile stretch for the former Delaware and Hudson between Scranton and Carbondale.

The Delaware and Hudson continued operating under dire financial straits for most of the decade. Under various auspices, the line continued running trains with aged locomotives and a deteriorating physical plant. In 1988, the line was cast into bankruptcy by then owner Guilford Rail System. Operated for a number of years in receivership, the Delaware and Hudson was acquired by the giant Canadian Pacific Railway in 1991. Following years of investment by its new owner, the former Delaware and Hudson is now a vital component of its owner's transcontinental system.

During those same years, the Lackawanna County Railroad Authority acquired most of the former Conrail trackage in the area, including the former Delaware, Lackawanna and Western trackage east from Scranton to Mount Pocono. Its sister organization, the Monroe County Railroad Authority, busied itself acquiring trackage from Mount Pocono eastward. The two organizations merged in 2006, and the resulting Pennsylvania Northeast Regional Railroad Authority controls trackage as far as Portland, Pennsylvania, in the Delaware Water Gap. The long-term goal is to restore the abandoned line across the Delaware River about 25 miles into New Jersey where a connection to active trackage can be reestablished.

As the designated operator of the lines owned by the railroad authority, the Delaware-Lackawanna Railroad Company currently operates daily freight service to a multitude of customers over these lines. Through ingenuity and determination, the railroad has brought customers back to the railroad and has witnessed a significant increase in rail traffic.

This 1982 scene typifies the former Delaware and Hudson Railroad main line at the time. Having moved the bulk of its traffic onto its newly acquired former Delaware, Lackawanna, and Western Railroad main line, the original line was allowed to deteriorate and saw only local service. Here a run-down locomotive leads a short train on poor track past a decaying former station in Dickson City. (Railroad Avenue Enterprises, Bob Pennesi photograph.)

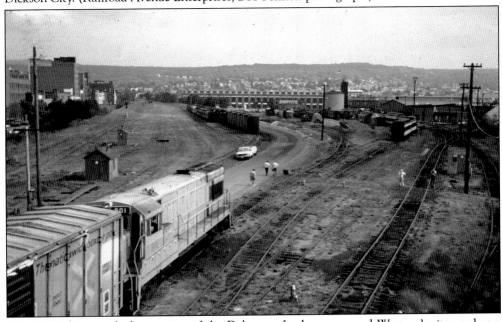

This 1991 photograph shows ruins of the Delaware, Lackawanna and Western's city yard as a local freight operating under the auspices of the Lackawanna County Railroad Authority arrives at Bridge 60. The vacant tracks to the photographer's left are now occupied by a shopping center, while the buildings to the right comprise today's Steamtown National Historic Site. (National Park Service, Ken Ganz photograph.)

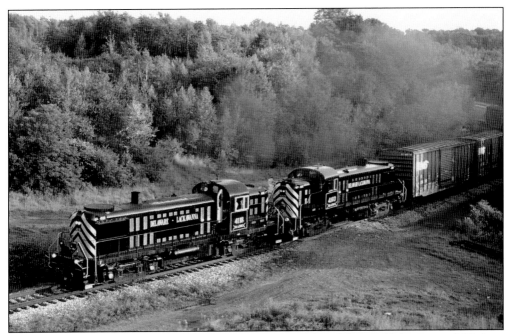

The Delaware-Lackawanna Railroad still operates 16 miles of former Delaware and Hudson trackage between Scranton and Carbondale. Here two RS-3-type locomotives once owned by the Delaware and Hudson work their way northward on their original line toward Carbondale in September 2001. (Author's collection.)

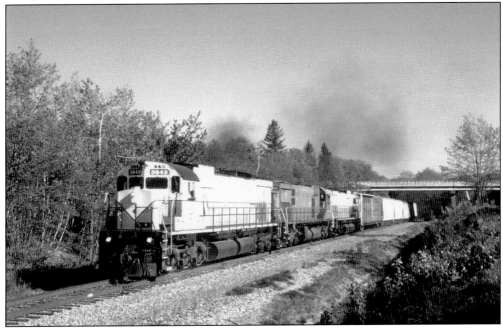

Three six-axle diesels lift a heavy train through the Pocono Mountains in 2006. As in the days of old, heavy trains like this 50-car freight require several locomotives to climb the grades east of Scranton. Locomotives with combined strength of over 10,000 horsepower are at the head of this train as seen in 2006. (Author's collection.)

This 1987 photograph presents a veritable history of Delaware and Hudson Railroad ownership. In front, a Guilford Rail System diesel illustrates that company's occupation of the Delaware and Hudson at the time. Behind engine No. 640, a battered Delaware and Hudson GP-38 can be seen. In the upper left, a Canadian Pacific Railway boxcar foreshadows the line's future owner. (Ken Ganz photograph.)

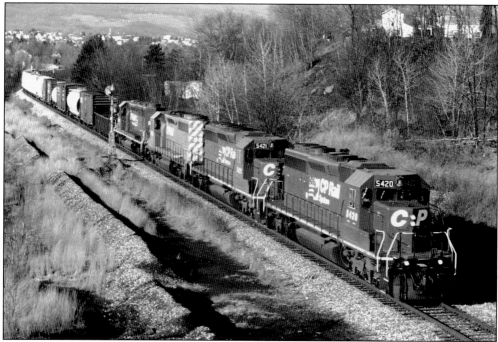

Today's Delaware and Hudson Railroad is a vital and healthy component of the Canadian Pacific Railway's transcontinental system. In this 1999 photograph, a main line freight passes through Avoca, several miles south of Scranton. (Ken Ganz photograph.)

Eight

HISTORY LIVES ON

In the midst of the rail revitalization discussed in the previous chapter, another remarkable event took place as Steamtown USA relocated to Scranton from Bellows Falls, Vermont. The railroad museum and excursion operation had faltered in its rural Vermont home for some time and selected Scranton as its new base of operations in 1983. Starting in 1984, Steamtown USA operated excursions over the former Delaware, Lackawanna and Western Railroad to the east of Scranton on tracks leased from Conrail before suffering a financial collapse in late 1987. Meanwhile, Congress created Steamtown National Historic Site in 1986 with an eye toward acquiring the collection of locomotives as well as the former Delaware, Lackawanna and Western yard in downtown Scranton. The National Park Service began administering the site in 1988 after the collapse of Steamtown USA and resumed the operation of steam excursions a year later. In 1995, the site held a grand opening for its multimillion-dollar roundhouse and museum facility. Today the site entertains and educates thousands of visitors each year with excursions, interpretive programs, and steam operations in yard.

The relocation of Steamtown USA heralded the arrival of so-called heritage tourism in the Lackawanna Valley. In addition to the steam trains, visitors can now explore the Scranton Iron Furnaces, which played such a key role in the development of the area, and tour the Pennsylvania Anthracite Heritage Museum, both administered by the Pennsylvania Historical and Museum Commission. Lackawanna County had the foresight to preserve an authentic coal mine, and today visitors to the area can journey into the earth on the Lackawanna Coal Mine tour.

Amazingly, a portion the former Lackawanna and Wyoming Valley Railroad has been resurrected as well. Today trolleys from the Electric City Trolley Museum take passengers for a 10-mile round-trip from Scranton to the booming sports and retail district at Montage Mountain. Far from just a tourist venture, the former interurban line also sees several Delaware-Lackawanna Railroad freight trains each week.

In an incredible transformation, Scranton has become a tourist destination and a thriving city once more, and the railroad is at the heart of it all again.

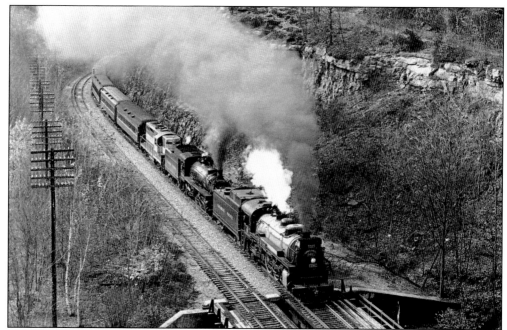

In September 1984, Steamtown USA began operating excursions in Scranton. That first season of trips saw massive crowds and sellout trains. In this photograph, two steam locomotives accelerate out of Scranton with a diesel along for the ride. Steamtown USA faced many hurdles in the coming years and ceased running trains after the 1987 season. (Tom Nemeth photograph.)

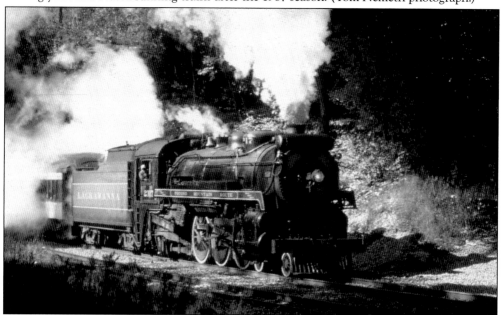

In 1986, Steamtown USA embarked on a program to re-create the Delaware, Lackawanna and Western Railroad. All the operating equipment was painted in the late-1940s gray and maroon paint scheme used on the line, often with dubious results. Here "Lackawanna" No. 2317, in actuality a veteran of the Canadian Pacific Railway, exits the Nay Aug tunnel in a cloud of smoke and steam. (Ken Ganz photograph.)

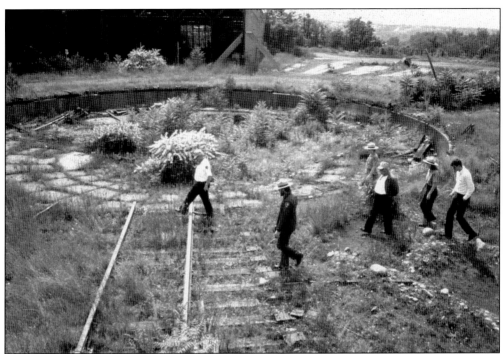

These two photographs illustrate the incredible revitalization of an abandoned railroad facility. In the photograph above, National Park Service employees and volunteers survey the remains of the Delaware, Lackawanna and Western's downtown roundhouse in 1988. Ten years later, a restored steam locomotive rides a replica turntable in the center of Steamtown National Historic Site's museum complex. Both images were captured from the same vantage point. (National Park Service, Ken Ganz photographs.)

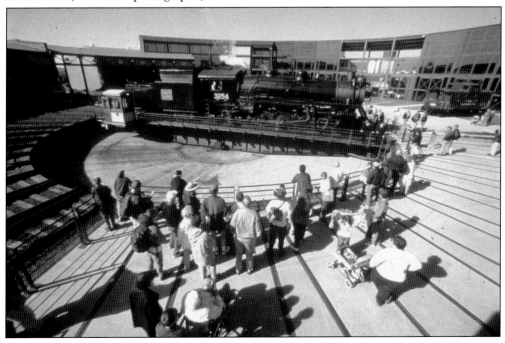

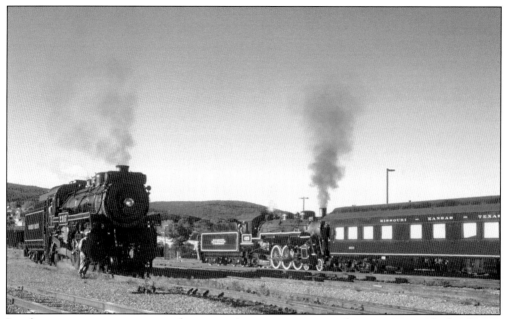

In what was once a common sight across America, two steam locomotives work the former Delaware, Lackawanna and Western Railroad yard in Scranton. Steamtown National Historic Site's former Canadian Pacific Railway locomotive No. 2317 is drifting through the yard while engine No. 425 on loan from the Reading and Northern Railroad has just arrived with an excursion train in this 1995 view. (Author's collection.)

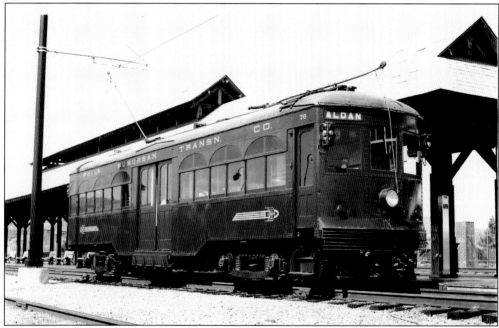

Restored trolley cars now traverse a portion the former Laurel Line interurban line to Montage Mountain, a retail and recreation area five miles south of Scranton. This route takes passengers through the nearly one-mile-long tunnel under the city's South Side and terminates at the base of Montage Mountain. (Author's collection.)

BIBLIOGRAPHY

Bux, Joseph, and Edward Crist. *New York, Ontario & Western Railway: Scranton Division.* Middletown, NY: Prior King Press, 1985.

Henwood, James N. G., and John G. Muncie. *Laurel Line: An Anthracite Region Railway.* Eynon, PA: Tribute Books, 2005.

Hiddlestone, Jack. *A Return to Scranton Luna Park.* Tunkhannock, PA: Mulligan Printing, 1991.

Kashuba, Cheryl A., Darlene Miller-Lanning, and Alan Sweeney. *Scranton.* Charleston, SC: Arcadia Publishing, 2005.

Percival, Gwendoline E., and Chester J. Kulesa. *Illustrating an Anthracite Era: The Legacy of John Horgan Jr.* Harrisburg, PA: Pennsylvania Historical and Museum Commission, 1995.

Perry, Daniel K. *A Fine Substantial Piece of Masonry.* Harrisburg, PA: Pennsylvania Historical and Museum Commission, 2000.

———. *Pennsylvania's Northeast Treasures.* Mayfield, PA: Heritage Valley Press, 2007.

Ruth, Philip. *Of Pulleys and Ropes and Gear.* Honesdale, PA: Wayne County Historical Society, 1997.

Yungkurth, Chuck. *Trackside around Scranton, PA, 1952–1976, with Edward S. Miller.* Scotch Plains, NJ: Morning Sun Books, 1999.

DISCOVER THOUSANDS OF LOCAL HISTORY BOOKS FEATURING MILLIONS OF VINTAGE IMAGES

Arcadia Publishing, the leading local history publisher in the United States, is committed to making history accessible and meaningful through publishing books that celebrate and preserve the heritage of America's people and places.

Find more books like this at
www.arcadiapublishing.com

Search for your hometown history, your old stomping grounds, and even your favorite sports team.

Consistent with our mission to preserve history on a local level, this book was printed in South Carolina on American-made paper and manufactured entirely in the United States. Products carrying the accredited Forest Stewardship Council (FSC) label are printed on 100 percent FSC-certified paper.

MADE IN THE
USA